3-31 81

EGON SCHIELE

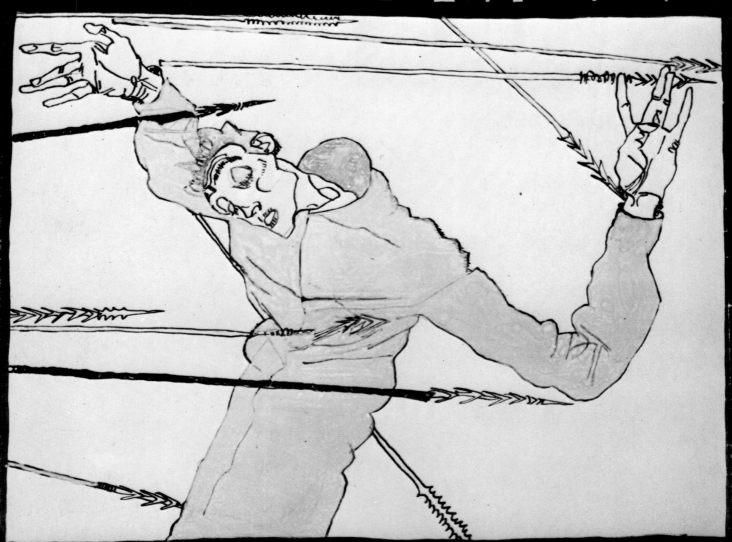

EGON SCHIELE

Simon Wilson

A Phaidon Book

CORNELL UNIVERSITY PRESS

ITHACA, NEW YORK

CONTENTS

© 1980 by Phaidon Press
Limited, Oxford

First published 1980 by Cornell
University Press.

International Standard Book
Number 0-8014-1330-3
Library of Congress Catalog
Card Number 80-548

Printed in Great Britain by
Waterlow (Dunstable) Ltd

SELECT BIBLIOGRAPHY

Alessandra Comini, *Egon Schiele's Portraits*, Berkeley, University of California Press, 1974

Alessandra Comini, *Schiele in Prison*, London, Thames and Hudson, 1974

Catalogue of Exhibition at Fischer Fine Art Gallery, London, November—December 1972

Rudolph Leopold, *Egon Schiele, Paintings, Watercolours, Drawings:Catalogue Raisonné*, London, Phaidon Press, 1973

Catalogue of Exhibition at Marlborough Gallery, London, October 1964

Catalogue of Exhibition at Marlborough Gallery, London, February—March 1969

Erwin Mitsch, *The Art of Egon Schiele*, Oxford, Phaidon Press, 1975

Peter Vergo, *Art in Vienna 1898–1918*, Oxford, Phaidon Press, 1975

Frontispiece. *Self-Portrait as Saint Sebastian* (poster design for Galerie Arnot). 1914–15. Indian ink and gouache, 67 × 50 cm. (26⅜ × 19⅝ in.) Vienna, Historisches Museum der Stadt Wien

LIST OF PLATES

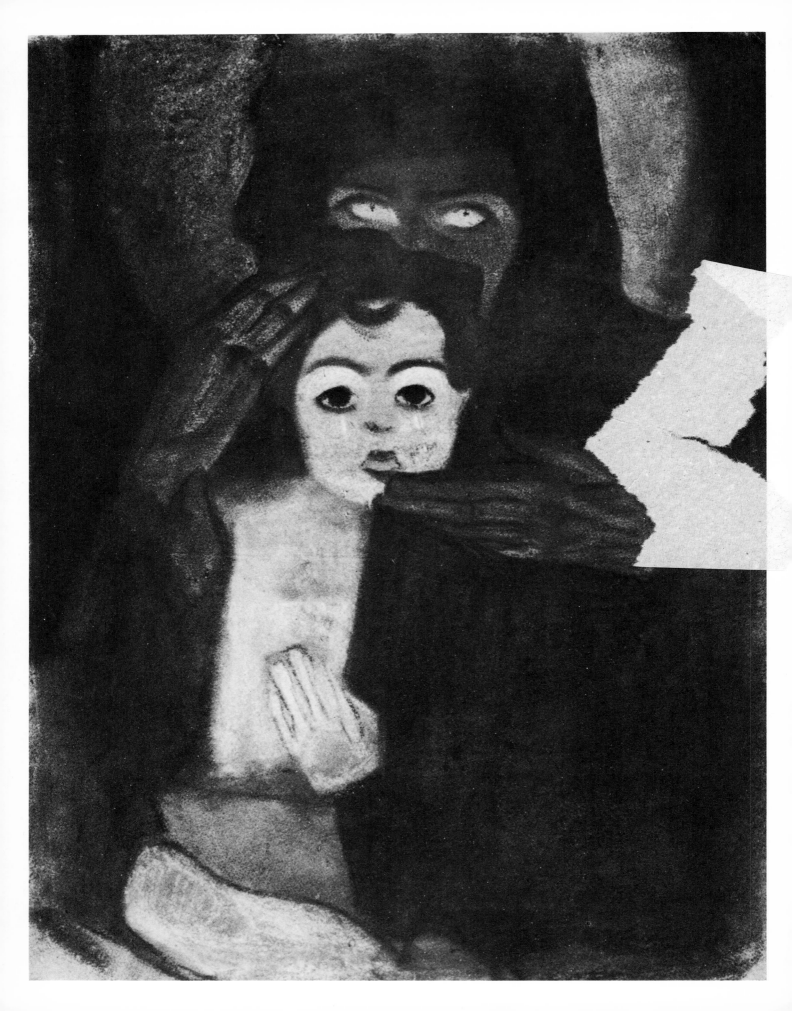

EGON SCHIELE

Egon Schiele died on 31 October 1918 at the age of twenty-eight, killed by the great 'flu epidemic which swept Europe at the close of the First World War. 'The war is over,' his sister-in-law reported him saying as he died, 'and I must go. My paintings shall be shown in all the museums of the world.' This prophecy has never been quite fulfilled, since much of Schiele's work remains in his native Vienna, but there is no doubt that his own estimate of himself as a genius is a correct one: we see him now as an outstanding figure in the early history of modern art, in spite of his premature death and consequently truncated career. In fact his life's work does not appear at all incomplete, and it may be suggested that, in the rich flood of amazing paintings, drawings and watercolours he produced in the years of his maturity from 1910 to 1918, he said all that he had to say and had taken his art to its fullest possible development. His dying words, if accurately reported, can even be taken to imply that he himself was conscious of this.

Schiele's importance lies in his outstanding contribution to the development of what is arguably the most significant and most typical of all modes of modern art—Expressionism. Expressionist art at its highest, as in the work of Schiele, achieves a perfect synthesis and balance between the modernist demand for abstraction—for an autonomous art independent of appearances—and the powerful European 'Renaissance' tradition in which man is represented naturalistically and themes expressed through narrative, symbol and allegory.

With Expressionism the modern artist, unlike his abstract colleagues, continues to deal with the great humanist themes of the Renaissance tradition but does so in a fresh and new way. He grapples directly with the reality he depicts, reshaping and re-creating it so that it becomes a new independent pictorial entity, a kind of super reality charged with the psychic power of the artist's vision, with his ideas, feelings and emotions. This reshaping is not only of form but of colour and texture—the actual handling of paint—as well. Indeed the use of colour for effect rather than description, that is expressively rather than naturalistically, is central to Expressionist art. Similarly, the surfaces of Expressionist paintings are never imitative—the paint is applied freely, under the impulse of the artist's inspiration, so that in some way the very texture of the paint becomes infused both with his feelings about the object, which it still nevertheless represents, and with the pure vitality or dynamism of the creative process—the paint surface is alive, not flat and dead.

Very interestingly, in Schiele's case the whole Expressionist process

2. *Madonna and Child.* c.1906. Red chalk with white chalk and charcoal heightening. Vienna, Niederösterreichisches Landesmuseum

is sometimes made dramatically clear where surviving photographs of his models can be compared with his drawings of them. For example, there is a remarkable photograph of 1911 by Schiele himself of his sister-in-law Adele Harms sitting in underclothes, black stockings and ankle boots. A watercolour of the same year is clearly based on this photograph. The photograph is only mildly erotic but in the watercolour Schiele has restructured the face and body of the woman so that the whole image crackles with the sexual tension the artist himself evidently felt. The work no longer represents, as does the photograph, the appearance of a particular person, but is the visual embodiment of one of man's most primitive, powerful and important instincts.

Schiele's remarkable ability to create direct visual equivalents for his feelings is one of the reasons for his stature as an early Expressionist. Another is the interest and importance and continuing relevance of the major themes of his art. One of these is that of sexuality, of man as above all a sexual being, but another equally important is that of *Angst* —the sense of spiritual anguish and despair that comes from the belief, or perception, common particularly to modern man, that human existence is without meaning and is a process of continual suffering and striving. Closely connected with this is the sense of mortality, the constant awareness of death, and this too is recurrent in Schiele's art. At the same time he was deeply obsessed with the self, again a very modern preoccupation.

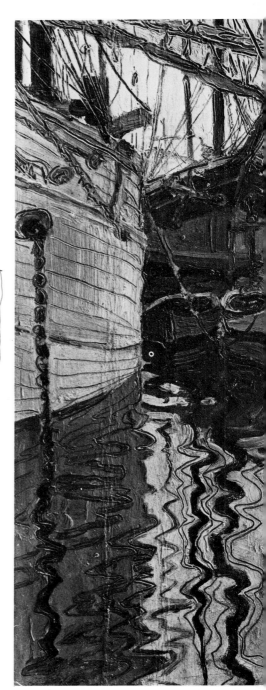

As all commentators on Schiele have pointed out, his career as an artist in Vienna coincided with the birth of psychoanalysis in the same city, and his preoccupations with sexuality and the self echo, reflect, or simply parallel those same concerns of the psychoanalytic movement. The profound influence undoubtedly exercised in Western society by Freudian thought, particularly in the last two decades or so, could be an important factor affecting our present perception of the modernity and relevance of Schiele's art. In fact Schiele's reputation slumped drastically after his death, reaching its nadir in the 1930s (when he was classed a 'degenerate artist' by the Nazis) and 1940s. It was not until 1960, and in America, that the first major one-man Schiele exhibition since 1928 was held. This was followed by one in Austria in 1963 and in London in 1964.

Another theme of Schiele's art is the relationship of the artist to society. Broadly speaking Schiele saw the artist as a kind of god, privileged and outside the rules of the normal social world. He seems to have been genuinely bewildered, as well as being moved to contempt and anger, by the indifference, incomprehension or hostility with which his work was largely greeted. (It was only in the last year of his life, ironically, that he began to find a wider appreciation.) Indeed, a number of his self-portraits quite overtly present him as a saint and martyr—the most obvious example being the self-portrait as Saint Sebastian he drew for the poster of his one-man exhibition at the Galerie Arnot in January 1915 (Frontispiece). Such an extreme view of society's attitude towards him was not in fact altogether unreasonable: on 13 April 1912, in the town of Neulengbach near Vienna, where he

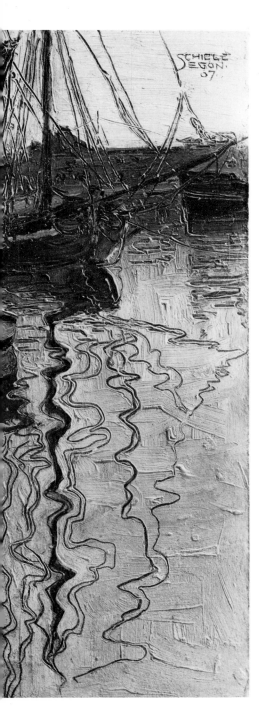

3. *View of Trieste Harbour*. 1907.
Oil and pencil on cardboard,
25 × 18 cm. (9⅞ × 7⅛ in.) Graz,
Neue Galerie am
Landesmuseum Joanneum

was living and working at the time, he was arrested and imprisoned for twenty-four days on two charges, of immorality and seduction of a minor. In addition to the sentence, and possibly of greater symbolic importance to Schiele, one of his drawings was ritually burned by the judge as a gesture of condemnation of his work.

A characteristic of Schiele's art is its intense visual richness—its purely abstract or decorative qualities of design and colour, which are often of a very high order. It is this, in combination with his extra-ordinary power of expression and the significance of his themes, which places him among the greatest of the moderns.

The themes of Schiele's art are expressed principally through the two aspects of the world which most interested him—women and himself—and his work is dominated by female nudes and self-portraits, many of these nude. There is also an important group of allegorical or symbolic works almost all of which are basically self-portraits or, when multi-figure compositions, include self-portraits. A fourth category is his portraits of other people. These are often also important vehicles for his own vision and feelings even when the result of straightforward society commissions, as in the case, for example, of his 1914 portrait of Friederike Beer (Plate 66). Finally, Schiele did respond strongly to landscape, and throughout his career he seems to have turned regularly to landscape painting, perhaps as a relief from the stresses of his other work.

FROM SYMBOLISM TO EXPRESSIONISM

Egon Schiele was born in Tulln, about forty miles west of Vienna, on 12 June 1890. His father was the town stationmaster and his grand-father had been general inspector of the Imperial Royal Privileged West Railway of Bohemia. He had two elder sisters, and in 1894 a third was born, Gertrude, to whom Schiele was to become particularly close. His father had syphilis, contracted before his marriage, and eventually died of general paralysis of the insane in the night of 31 December 1904—1 January 1905, when Schiele was fourteen.

In spite of the lack of artistic traditions in his background, it seems clear that Egon Schiele was something of a prodigy or *Wunderkind*. His mother reported him starting to draw at the age of eighteen months and his sisters described him drawing 'uninterruptedly from morning to night'. Schiele went to elementary school in Tulln, but apparently formed few friendships, spending his leisure time sketching. In 1901 he was sent to the nearest *Gymnasium* (grammar school) at the town of Krems, but the following year his family moved to Klosterneuburg and Schiele was moved to the Abbey School there. Except in art, he was not a successful pupil and later wrote of this period of his life, 'During this time I suffered the death of my father. My loutish teachers were my perpetual enemies. They—and others—did not understand me.'

From 1905, however, Schiele appears at least to have been taught art well at the Abbey School by a teacher he could admire, Ludwig Karl

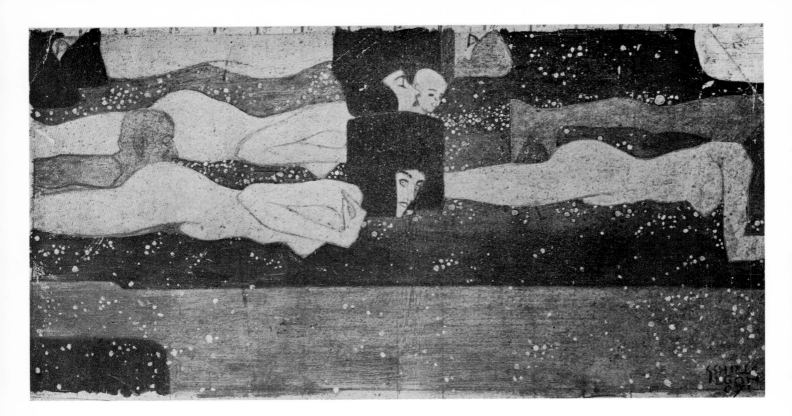

4. *Watersprites I*. 1907. Mixed media, gouache, crayon, gold and silver paint on paper, 24 × 48 cm. (9½ × 18⅞ in.) Private collection

Strauch, a painter with some local reputation. By 1906, perhaps as a result of Strauch's sympathetic tutelage, Schiele was producing works which reveal not only a rapidly growing technical accomplishment but, perhaps more importantly, the beginnings of a personal vision. Among these are self-portraits which are already memorable for their degree of romantic intensity and self-obsession, such as the charcoal drawing of 1906 now in the Albertina Museum in Vienna, and also fully fledged Symbolist compositions like the 1906 *Madonna and Child* (Plate 2).

Here some brief account must be given of Symbolism, its place in the complex development of modern art and, especially, its relationship to Expressionism. Although its history can be traced back to the late eighteenth century, what we call modern art really began in the middle of the nineteenth century with a major rejection by artists of talent of the norms in style, theme and iconography of the Renaissance tradition, which had been dominant in Europe since the sixteenth century. In particular there was a rejection of what was known as history painting—the painting of historical, mythological, biblical and literary subjects. Instead artists turned back to the immediate world of experience, and from about 1850 a major movement developed known as Realism. This in turn gave rise to Impressionism, in which increasing emphasis was placed on purely pictorial values. To over-simplify grossly, out of all this emerged various forms of abstract art in the early twentieth century. But, of course, the Renaissance idea did not simply go away. Indeed, perhaps under the stimulus of Realism, it found renewed life in a phase of late nineteenth-century art now known as Symbolism, an art in which, broadly, man and his emotions rather than simply external reality remained the central subject. Symbolism did, in its own way, share the Realist/Impressionist preoccupation with visual effect, and Symbolist art is characterized by heavy stylization. The image of reality is increasingly given its own independent, often highly decorative

pictorial structure, which tends to be expressive *in itself* of the content
of ... in his Symbolist *Madonna and Child* Schiele pro-
... mystery by placing the figures in a hieratically
... by rendering the forms as flattened silhouettes alternately
... treatment of the Madonna's eyes, which
... of darkness while the rest of her face remains hidden, and by
the treatment of the hands, elongated, disembodied, mystically gestur-
ing and placed in a deliberately triangular configuration to symbolize
the Trinity.

Symbolism was the immediate forerunner or precursor of modern
Expressionist art, and one of the most fascinating and significant
aspects of Schiele's career is the way in which the great shift from
Symbolism to Expressionism, one of the most vital transformations in
the early history of modern art, can be clearly traced in his work from
1906 to 1910. A crucial factor affecting his dramatic development in
these years was the presence in Vienna of one of the most dynamic of
the Symbolist groups in Europe, the Vienna Secession, and in par-
ticular its leading figure Gustav Klimt, that towering genius of
Symbolist art. A generalized influence of the Vienna Secession style

5. Gustav Klimt (1862–1919):
The Kiss. 1908. Oil on canvas,
180 × 180 cm. (70⅞ × 70⅞ in.)
Vienna, Österreichische Galerie

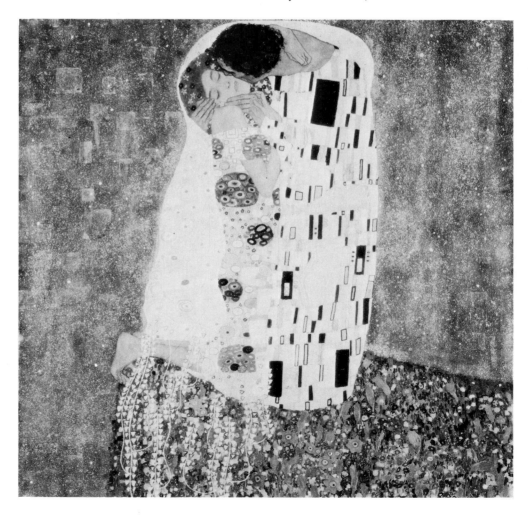

appears in Schiele's work from about 1906–7 and can be seen in paintings like the *View of Trieste Harbour* of 1907 (Plate 3): the emphasis on the boats as flat abstract shapes, and especially the treatment of the ripples on the water as a system of highly decorative curling lines are typically Secessionist. 1907 was also the year in which Schiele seems specifically to have become aware of Klimt himself, whose notorious and highly controversial mural paintings for the University of Vienna, *Philosophy, Medicine* and *Jurisprudence*, were exhibited together in that year at the Galerie Miethke in Vienna. Also in 1907 Schiele actually met Klimt for the first time. This meeting has given rise to one of those charming stories which frequently crop up in the history of art when aspiring youth seeks advice and approval from established genius. Schiele apparently handed to Klimt a portfolio of drawings with the words 'Do I have talent?' A long pause ensued while Klimt looked through the drawings; he then replied, 'Yes! Much too much!' Thus began, at first a discipleship, then a friendship, which continued until Klimt's death in February 1918, less than a year before that of Schiele himself. Schiele was with Klimt at the end and made a number of tender deathbed drawings of his mentor.

The first substantial overtly Klimt-like work by Schiele is the *Watersprites*, painted in 1907 (Plate 4), which is in fact very closely based on a similarly titled painting by Klimt of 1904, now in a private collection in Vienna. Derivative as it undeniably is, this work in gouache and gold and silver paint on paper nevertheless shows distinct, marked and important differences from Klimt. It is highly decorative, but does not have the extreme hothouse lushness of decorative effect characteristic of Klimt. Similarly the lush sensuality of Klimt's nudes, expressed through flowing curves and fully rounded forms, is replaced by a sharper eroticism communicated through flattened forms and rather angular outlines. The sleepy inviting eyes and sexy smile of Klimt's principal figure is replaced in the Schiele by a grimacing mouth and neurotic stare: Schiele is already finding his own voice, that of the *Angst*-ridden twentieth century, so very different in the end from the hedonistic, self-indulgent world of the late nineteenth century, of which the art of Klimt was the gorgeous, quintessential and final manifestation. This assimilation of Klimt can also be seen in certain nude drawings of 1908 such as *Girl Leaning Forward* (Plate 6).

For a short time, however, Schiele's own increasingly urgent personal vision of man was held at bay by the Symbolist heritage of Klimt. At the same moment his technical powers reached their full development and the result was a series of paintings executed in 1908 and 1909 which are among the final climactic masterpieces of European Symbolism. This group includes a number of portraits and self-portraits and an extremely striking version of the mythological subject of *Danaë*, which again, had earlier (1907–8) been treated by Klimt. For his own version, however, Schiele invented a pose of total originality: so much so indeed that Klimt later borrowed it for his *Leda* of 1917.

The most important of the portraits are those of Anton Peschka, Hans Massmann and Gertrude Schiele, the artist's sister, all painted in

6. *Girl Leaning Forward*. 1908. Black chalk, 45 × 31 cm. (17¾ × 12¼ in.) Private collection

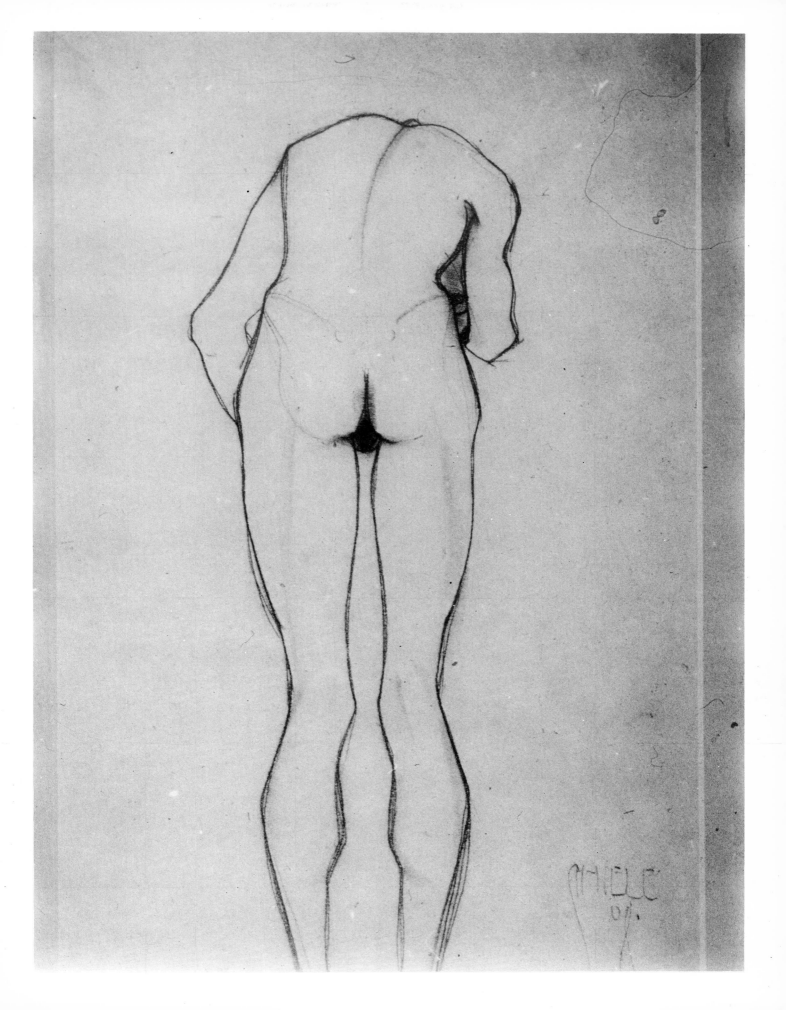

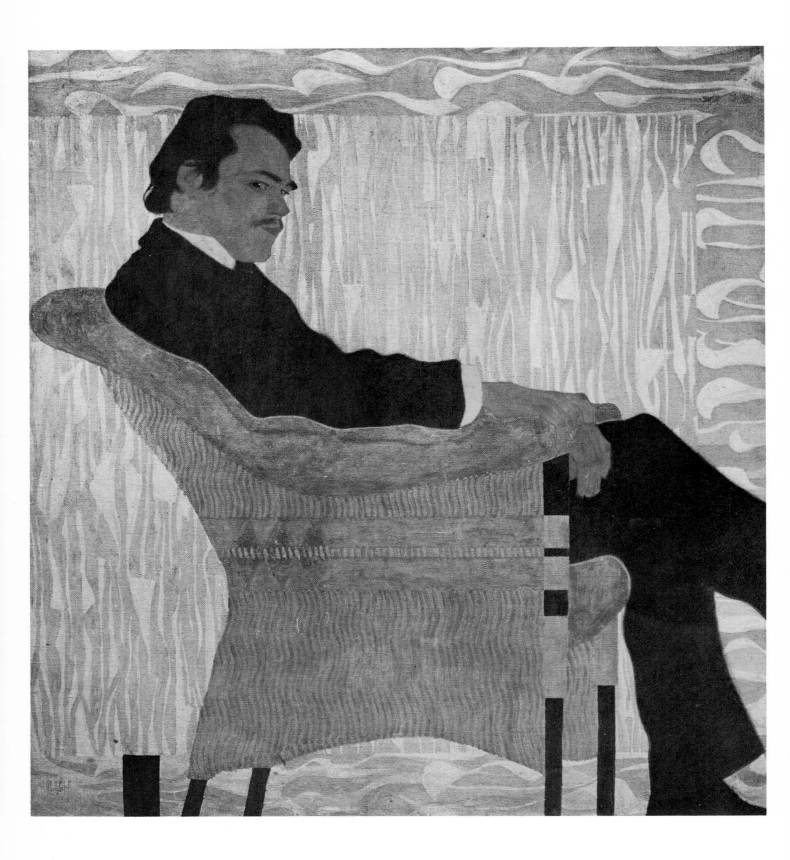

1909 (see Plates 7, 8), and to these can be added Schiele's remarkable semi-nude self-portrait, also of 1909 (Plate 11). Both the men were fellow artists and close friends of Schiele, and Peschka married Gertrude in 1914. Massmann had been a fellow student of Schiele at the Vienna Academy (Akademie der Bildenden Künste), which Schiele attended from 1906, leaving in 1909—about the time these portraits were painted. They coincide therefore with the start of Schiele's life as an independent adult as well as marking the first phase of his artistic maturity.

In the portraits of Massmann and Peschka and the self-portrait the influence of Klimt is still paramount, although they have of course, even more fully evolved, the same personal qualities of drawing and expression already noted in relation to the *Watersprites*. The self-portrait in particular is the first major statement in Schiele's art of his intense narcissism and the eroticism which was one of its major components. The elaborate treatment of the pubic hair as a luxuriant growth reaching right to the navel and there terminating in a distinct tuft is entirely characteristic of the obsessional and unprecedented attention Schiele was to pay to the rendering of genitalia and the secondary sexual characteristics of pubic and axillary hair.

The portrait of Schiele's sister, Gertrude, however, marks the beginning of a distinct stylistic shift away from Klimt. The drawing is

8. *Portrait of Gerti Schiele*. 1909. Pencil, oil, silver and gold bronze paint on canvas, 139.5 × 140.5 cm. (54$\frac{7}{8}$ × 55$\frac{3}{8}$ in.) Graz, collection of Viktor Fogarassy

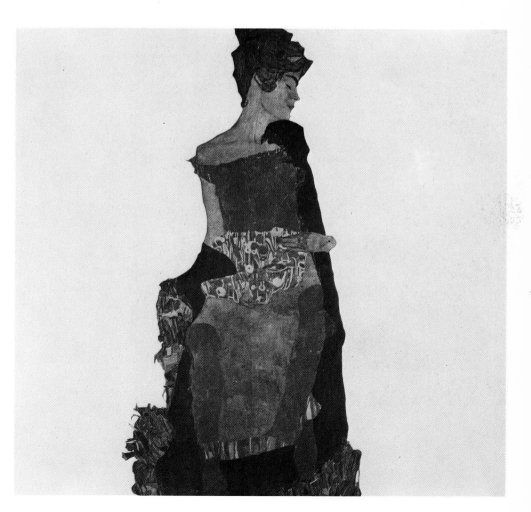

7 (left). *Portrait of Hans Massmann*. 1909. Oil, silver and gold paint on canvas, 120 × 110 cm. (47$\frac{1}{4}$ × 43$\frac{1}{4}$ in.) Private collection

increasingly angular, the decorative character less marked (although still very much there) and, most strikingly, the figure has been set against a completely blank background producing a powerful sense of isolation.

Schiele's departure from the Vienna Academy in 1909 was the result of what appears to have been a student revolt in which he and a group of fellow students presented the Director, Professor Griepenkerl, with a thirteen-part formal critique of the Academy's teaching methods. The dissidents withdrew in a body at the end of the Spring term of 1909 and promptly formed themselves into an *avant-garde* Neukunstgruppe (New Art Group) with Schiele as president. The first exhibition of the group was held at the Gallery Pisko in Vienna in December 1909. It was accompanied by a manifesto written by Schiele and later, in 1914, published in the periodical *Die Aktion* under the title *Die Kunst—Der Neukünstler* (*Art [and] the New Artist*).

It is worth pausing here to note the emphasis Schiele lays on the modernity not of *art* but of the artist. This idea was clearly very important to him: in the manifesto itself he wrote 'Art constantly remains equal and the same—art,' and in a letter of 1 September 1911 he stated, 'I know that there is no "modern" art, there is only one art, which is timeless.' Further, one of the drawings done in prison in 1912 is inscribed 'Kunst Kann Nicht Modern Sein; Kunst ist Urewig' (art cannot be modern, art is eternal). These aphorisms underline Schiele's aim simply to bring a modern sensibility to the great tradition of Western art rather than radically to reshape it as other *avant-garde* artists were doing in the first two decades of the twentieth century.

Two other events in Schiele's life in 1909 are notable. First, he established a connection with the Wiener Werkstätte (the Vienna Workshops), one of the most important of the organizations which all over Europe at that time were carrying out a revolution in the arts of design parallel to that taking place in the fine arts. Schiele received only minor commissions from the Wiener Werkstätte but the connection meant that at this point he was in close touch with both wings of the Vienna *avant-garde*. Secondly, he exhibited four works, two of which were the portraits of Hans Massmann and Anton Peschka already mentioned, at the 1909 International Kunstschau. This was the second of two large exhibitions, organized in Vienna in 1908 and 1909 by Gustav Klimt, which marked the climax of the art activity that had started with the foundation, by Klimt, of the Vienna Secession group in 1897. The first of these exhibitions included 21 works by Klimt and had given Schiele his fullest exposure to date to Klimt's work. The second gave him the opportunity to exhibit works of his own in which, as we have seen, the influence of Klimt is fully assimilated.

The 1909 Kunstschau also exposed Schiele to a further formative influence, that of the art of Edvard Munch and Vincent Van Gogh, the two great founding fathers in the late nineteenth century of the modern tradition of Expressionism. From these two artists Schiele seems to have gained an increased awareness of the possibilities of both a free handling of paint and the purely expressive, non-naturalistic use of

9. *Seated Nude*. 1910. Black crayon and aquarelle, 45 × 31.5 cm. (17¾ × 12⅜ in.) Vienna, Historisches Museum der Stadt Wien

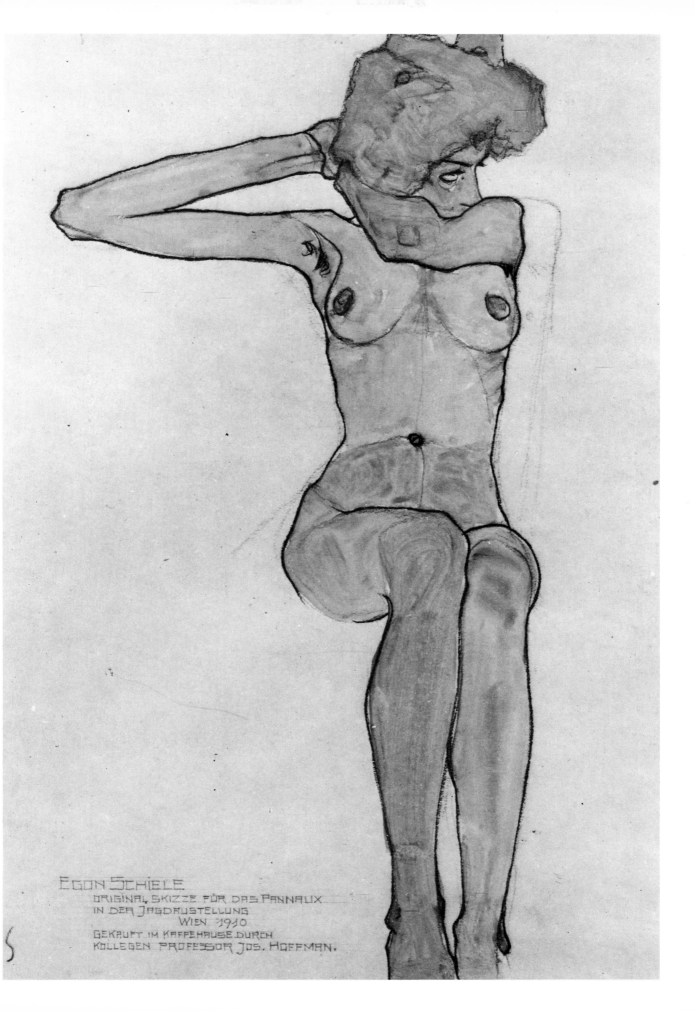

EGON SCHIELE
ORIGINAL SKIZZE FÜR DAS PANNALIX
IN DER JAGDAUSTELLUNG
WIEN 1910
GEKAUFT IM KAFFEHAUSE DURCH
KOLLEGEN PROFESSOR JOS. HOFFMAN.

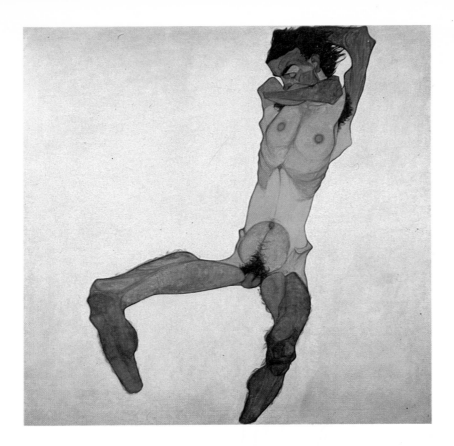

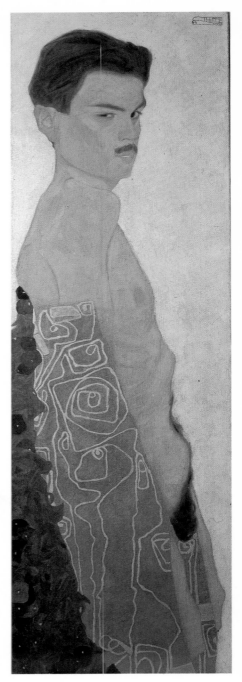

colour. He also perhaps received a more general stimulus towards finding his own direction. This may help to account for the changes observable in the late 1909 portrait of Gertrude. Certainly in 1909–10 Schiele's art underwent an extremely rapid evolution, and three major oil paintings of that year can be taken as the signposts of his full maturity: a seated male nude which is basically a self-portrait (Plate 10), a seated female nude, and a standing female nude for which the model was Gertrude Schiele. The original oils of the two female nudes have been lost but striking watercolour studies for each survive (Plates 9, 12). There is also a remarkable group of nude portrait drawings of the artist Mimi Van Osen, the wildest and most bohemian member of the Neukunstgruppe (Plate 13).

With these works Schiele emerges as one of the great originals of modern art, an artist whose work is now entirely *sui generis*. All external influences have disappeared or been so thoroughly assimilated as to become undetectable, and the last decorative trappings of Symbolism have been discarded. Schiele is now fully Expressionist, directly confronting reality in all its starkness and reshaping it in the image of his own vision.

Schiele's mature art presents us with an image of man, free-floating, seen from strange and unusual angles and in strange and unusual postures, that is quite new in the long history of the human image in Western art. He developed in other words a completely fresh view of man in art—an extraordinary achievement. But that is not all: Schiele's image of man is of an unprecedented and remarkable completeness. He depicts us as the sexual beings we are in a way no other great artist had ever done before, and at the same time gives full and equal value to the metaphysical and psychological.

10 (above left). *Seated Male Nude*. 1910. Oil and body-colour on canvas, 152.5 × 150 cm. (60 × 59 in.) Private collection

11 (above). *Self-Portrait I*. 1909. Oil on canvas, 110.5 × 35.5 cm. (43½ × 14 in.) Courtesy Marlborough Fine Art Ltd., London

12 (right). *Standing Female Nude with Crossed Arms*. 1910. Black chalk and watercolour, 48.8 × 28 cm. (19¼ × 11 in.) Vienna, Graphische Sammlung Albertina

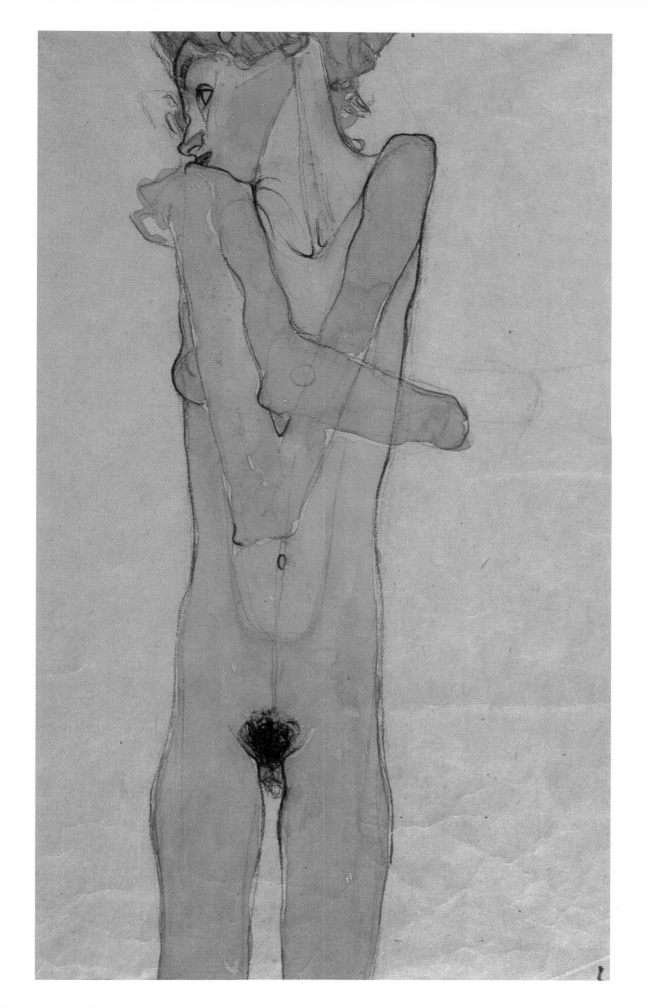

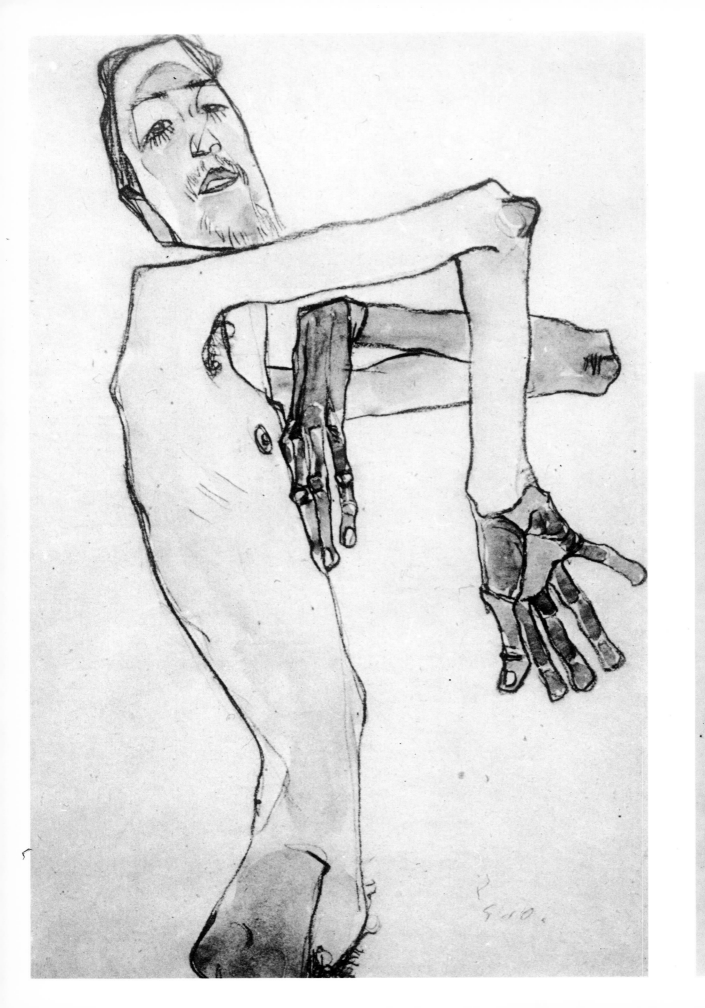

NUDE SELF-PORTRAITS: THE SELF, METAPHYSICAL AND SEXUAL *ANGST*

The full-length male nude painting of 1910 which is perhaps Schiele's first completely personal masterpiece in oils (Plate 10) is, as already mentioned, almost certainly a self-portrait although the face is barely visible. As such it marks the start of a series of nude, semi-nude or, very occasionally, clothed self-portraits which Schiele continued virtually to the end of his life (see Plate 14). However, his production of them appears to have been most intensive in respect of quantity, and perhaps also most intense in emotional quality, in the period about 1910–12. These self-portraits are the most significant, original and compelling works of the first year or so of Schiele's maturity: they form the core of

13 (far left). *Male Nude* (the painter, Mimi Van Osen). 1910. Black chalk, watercolour and gouache, 44.4 × 30.8 cm. (17½ × 12⅛ in.) Private collection

14 (below). *Self-Portrait Squatting*. 1918. Chalk, 30.1 × 47.1 cm. (11⅞ × 18½ in.) Vienna, Graphische Sammlung Albertina

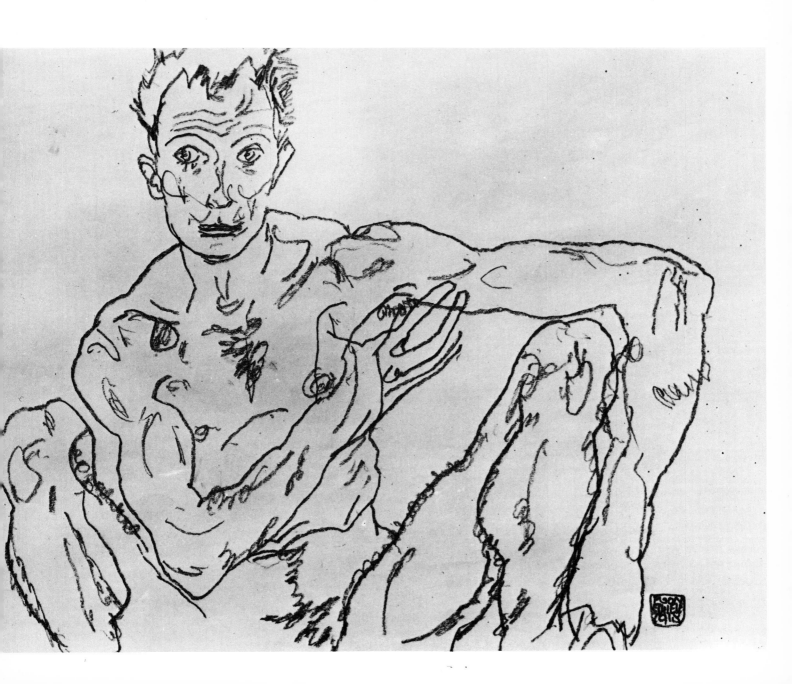

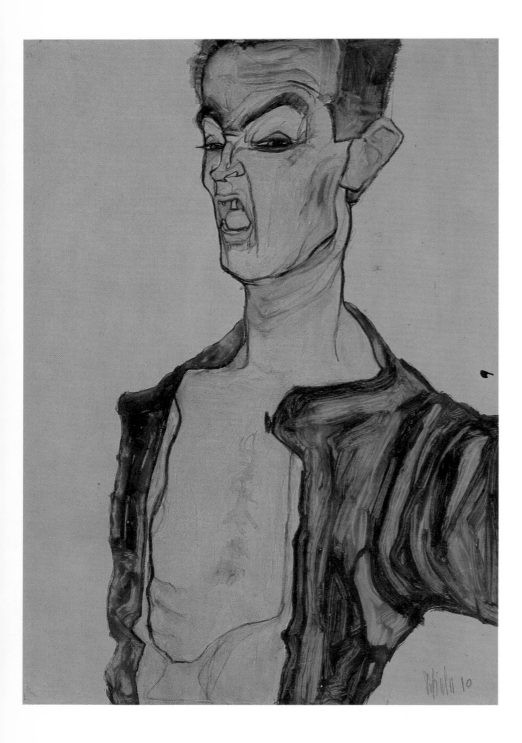

16 (right). *Self-Portrait, Nude Facing Front.* 1910. Pencil, watercolour, gouache, glue, white body-colour, 55.7 × 36.8 cm. (21⅞ × 14½ in.) Vienna, Graphische Sammlung Albertina

15. *Self-Portrait Screaming.* 1910. Watercolour. Graz, collection of Viktor Fogarassy

his art in that period although he was also working with great power in the fields of portraiture, the female nude, allegory and landscape.

The self-portraits can broadly be divided into those expressive of metaphysical *Angst* and those expressive of sexual *Angst*. In both categories of course Schiele is also obsessively concerned with the self,

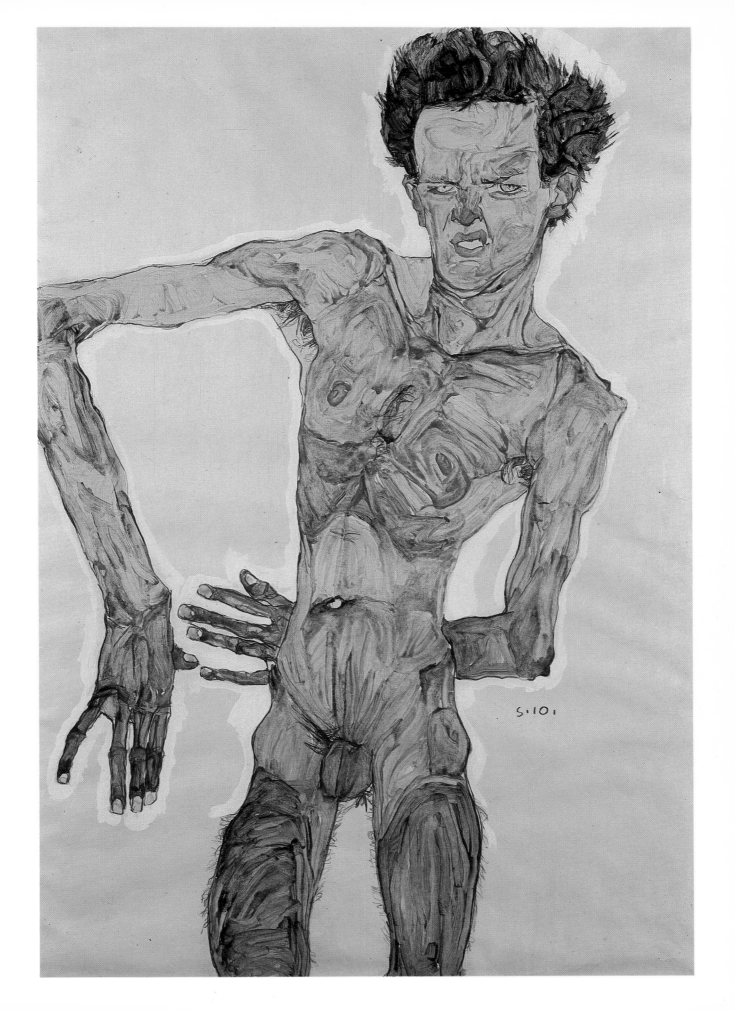

and there are one or two works in which this concern takes on a more specifically narcissistic character and reveals the important element of dandyism in the artist's personality. These will be discussed later in the context of the artist and society.

Most of the self-portraits are in watercolour but among the earliest is an oil *Self-Portrait Kneeling with Raised Hands* of 1910 (Plate 17). The original oil has disappeared but it is known from a photograph and from the study here reproduced. This work belongs with the metaphysical group, and the figure with its closed eyes, prominent hands and kneeling posture seems to suggest the artist blindly groping and crawling his way forward through existence. However, he seems at this point to have come to some invisible barrier against which he presses his right hand, and the image also becomes one of man as a being who is trapped. In reality, incidentally, the 'invisible barrier' of this work must have been the full-length pier glass that appears in a photograph of Schiele taken in 1916. According to Alessandra Comini, this huge mirror was begged by Schiele from his mother for his first studio in 1907, and in spite of its size and weight he took it with him whenever he moved: it was a fundamental tool of his art.

In the *Self-Portrait Kneeling with Raised Hands* Schiele puts great emphasis on the hands. Hands and gestures of hands can be, of course,

17 (below left). *Self-Portrait Kneeling with Raised Hands*. 1910. Black chalk, watercolour and gouache. Graz, collection of Viktor Fogarassy

18 (below right). *Torso*. 1911. Tempera and watercolour, 43.2 × 28.5 cm. (17 × 11¼ in.) Courtesy Fischer Fine Art Ltd., London

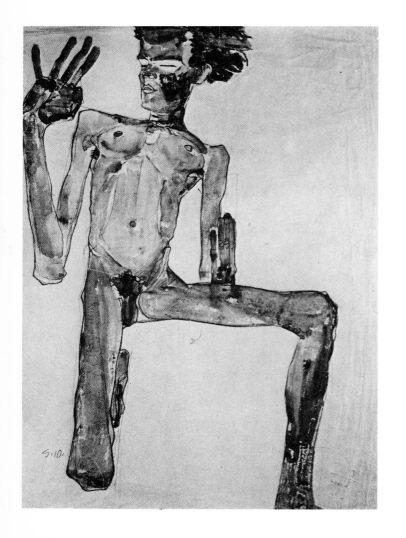

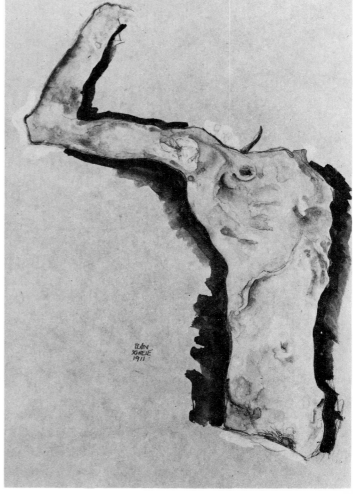

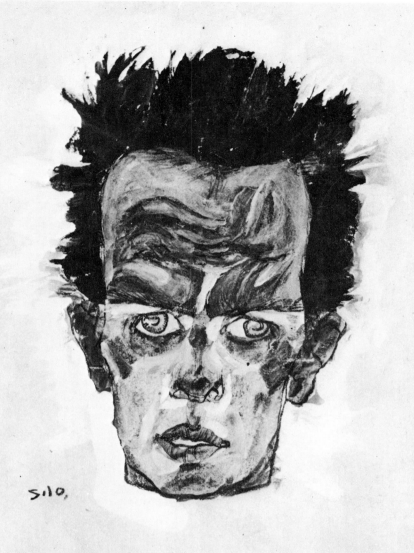

19. *Self-Portrait with Wrinkled
Forehead.* 1910. Watercolour.
Graz, collection of Viktor
Fogarassy

highly expressive; also, hands are the means of human creation in
general and of artistic creation in particular. An interest in hands is not
uncommon in art, but with Schiele it takes on obsessional proportions.
In his self-portraits Schiele frequently paints the hands in a character-
istic gesture with the fingers either slightly but distinctly parted or
spread in a positive V, or sometimes, as in *Self-Portrait Kneeling,* both
at once. The significance of these gestures is not entirely clear;
primarily they give the impression of some mysterious occult or
cabbalistic sign although it also seems not unlikely, as some commen-
tators have suggested, that there is a sexual meaning, both positions of
the spread fingers symbolizing the female parts.

A more specific and powerful vision of man as a being condemned to
intense spiritual suffering is *Self-Portrait, Nude Facing Front* of 1910
(Plate 16). Here the sense of *Angst* is expressed through a fully

25

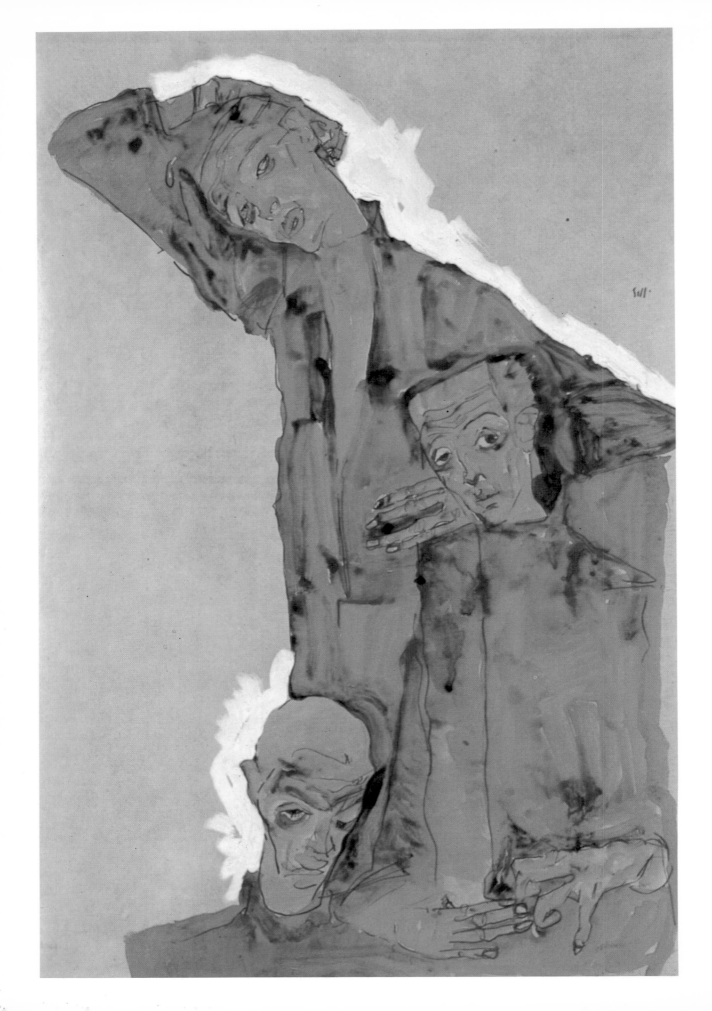

developed treatment of the body as a knobbly, bony, hairy, angular, emaciated structure placed in a pose of great tension. The tension is emphasized by the white halo, almost suggesting radiant energy, painted round the figure. The face is twisted into an appalling grimace. Three works very close to this in feeling, in which Schiele concentrates mainly on the face, are the *Self-Portrait with Wrinkled Forehead* of 1910 (Plate 19), the astonishing *Self-Portrait Screaming* also of 1910 (Plate 15), in which the livid expanse of chest also plays its part, and an oil painting of 1912, *Self-Portrait with Bare Drawn-up Shoulder*. This whole aspect of Schiele's art is taken to extremes in drawings such as *Torso* of 1911 (Plate 18), in which the body appears simply as a mutilated fragment.

One of the strangest of Schiele's early self-portraits is the triple one of 1911 known as *Composition with Three Male Figures* (Plate 20). Its composition is quite extraordinary, with the three figures rising above

20 (left). *Composition with Three Male Figures.* 1911. Pencil, watercolour, gouache, white body-colour, 55 × 37 cm. (21⅝ × 14⅝ in.) Private collection

21. *Self-Portrait with Hand to Cheek.* 1918. Black chalk and gouache, 44.3 × 30.5 cm. (17½ × 12 in.) Vienna, Graphische Sammlung Albertina

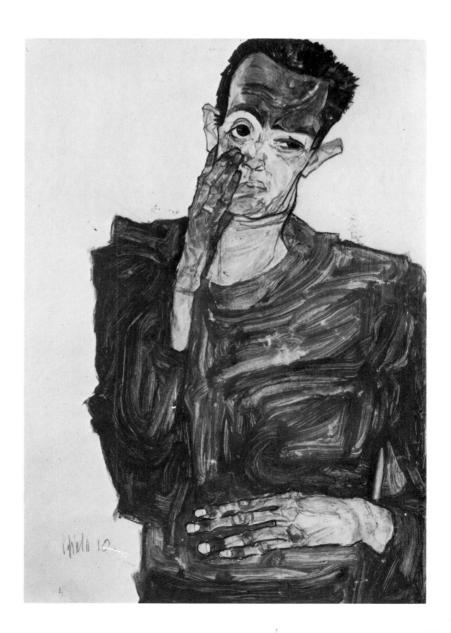

each other, the bodies blended together in flowing brushstrokes to make a bold shape enclosing an almost abstract field of colour from which only the faces, eyes and hands emerge with any clarity. Its meaning remains obscure but the head at the bottom, which is the most striking, seems to be that of a shaven-headed penitent. Together with the indistinct, immaterial quality of the whole image, with the marked spirituality of all the faces, and the overall hot monochrome red of the colour scheme, the suggestion is overwhelmingly of souls in torment.

The mysterious gestures of the hand, already discussed, play a prominent part in the 1910 *Self-Portrait with Hand to Cheek* (Plate 21), but here they are combined with another gesture, the finger dragging at the lower lid to expose the eye, which is also recurrent in Schiele's art. Alessandra Comini has put forward the convincing explanation that, whatever else it may mean, the gesture is a punning reference to the artist's name: in German the verb *schielen* means to squint, and apparently a number of hostile critics used this correspondence to make sarcastic jokes about Schiele's eyesight.

We can now turn to the sexual self-portraits. It seems clear that in adolescence Schiele developed exceptionally strong and insistent sexual impulses and that until he formed his first lasting heterosexual relationship in the autumn of 1911 with the model Wally Neuzil these impulses had no regular or legitimate outlet other than masturbation. This, on the evidence of certain self-portrait drawings of 1910–11, Schiele practised intensively for a time, and made it the subject of his art. In these extraordinary drawings he elevates his own sexual feelings into a general comment on the distortion of the sexual instincts in modern civilized European society, in which sexual repression was (and to some extent still is) integral to the social structure. One result of predominantly Puritan social attitudes is that the individual is likely to develop feelings of conflict and guilt about his own sexuality, to the extent that when very powerful it can appear as a monstrous burden, a kind of martyrdom. Schiele, in 1912, in his prison diary, wrote the following astonishing words which reveal that this was indeed the nature of his experience; these words provide an important key to the understanding of his art:

> Have adults forgotten how corrupted, that is incited and
> aroused by the sex impulse, they themselves were as
> children? Have they forgotten how the frightful passion
> burned and tortured them while they were still children?
> I have not forgotten, for I suffered terribly under it.
> And I believe that man must suffer from sexual torture
> as long as he is capable of sexual feelings.

It is this sense of 'sexual torture' that Schiele brilliantly and absolutely unforgettably depicted in a series of drawings of himself both in the act of masturbation and in the throes of orgasm. Of those showing the act itself the most explicit is the one inscribed 'Eros' in which the artist's engorged phallus juts out towards the spectator against the backdrop of tormented face and body (Plate 24). Another work in this group (Plate 23) is more ambiguous, although identified

22. *Nude Self-Portrait.* 1910. Pencil, watercolour, gouache and glue. Vienna, Graphische Sammlung Albertina

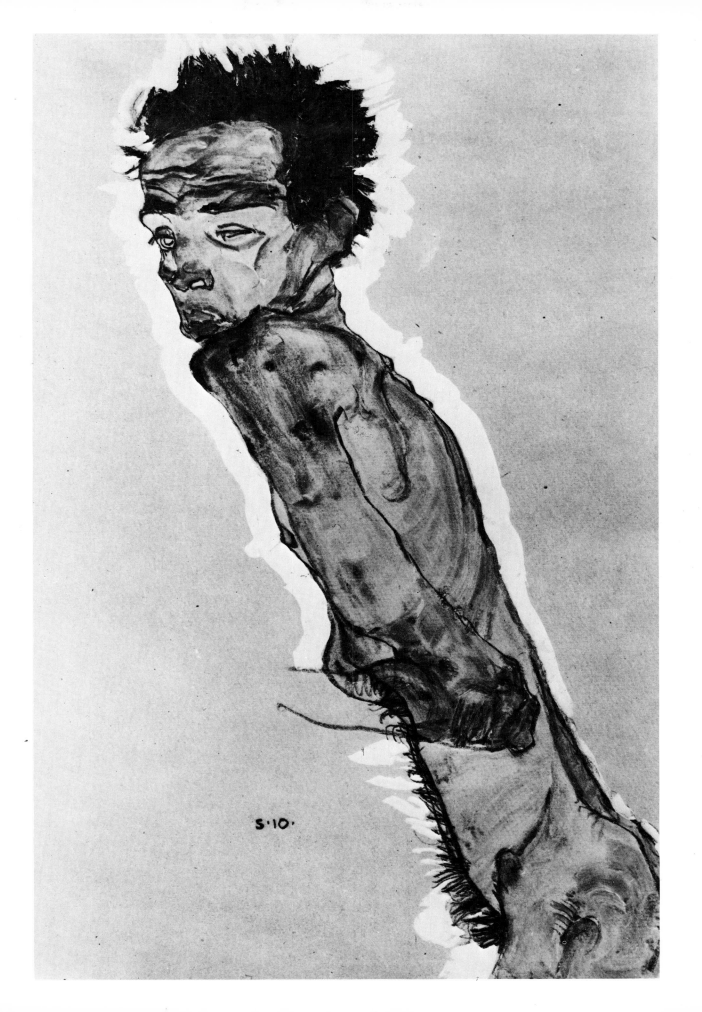

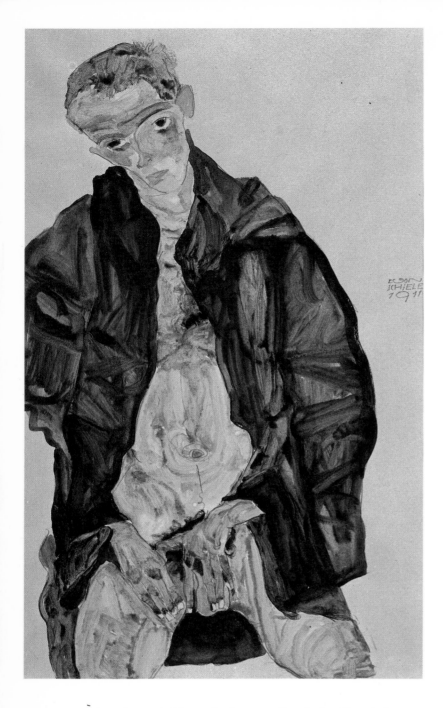

23. *Self-Portrait Masturbating*.
1911. Pencil and watercolour,
47 × 31 cm. (18½ × 12¼ in.)
Vienna, Graphische Sammlung
Albertina

firmly by Comini as a masturbation picture. The ambiguity arises from
Schiele's placing of his hands over his genitals and arranging them not
merely to *symbolize* female sexual parts as in for example Plate 17, but
to create quite literal representations of them: a triangle of pink flesh
and pubic hair between his forefingers and left thumb and a more
specifically vulval effect between the first and second fingers of the left
hand. The possible significance of this imposition of female genitals on
his own is discussed on page 57.

Among the drawings of orgasm one of the most striking is that of
1910, known simply as *Nude Self-Portrait* (Plate 22), in which Schiele
has perfectly captured, in the unfocused eyes and sagging lopsided
features of the face, the sense of helplessness and dissolution that occurs
at the moment of orgasm when all conscious mental and physical

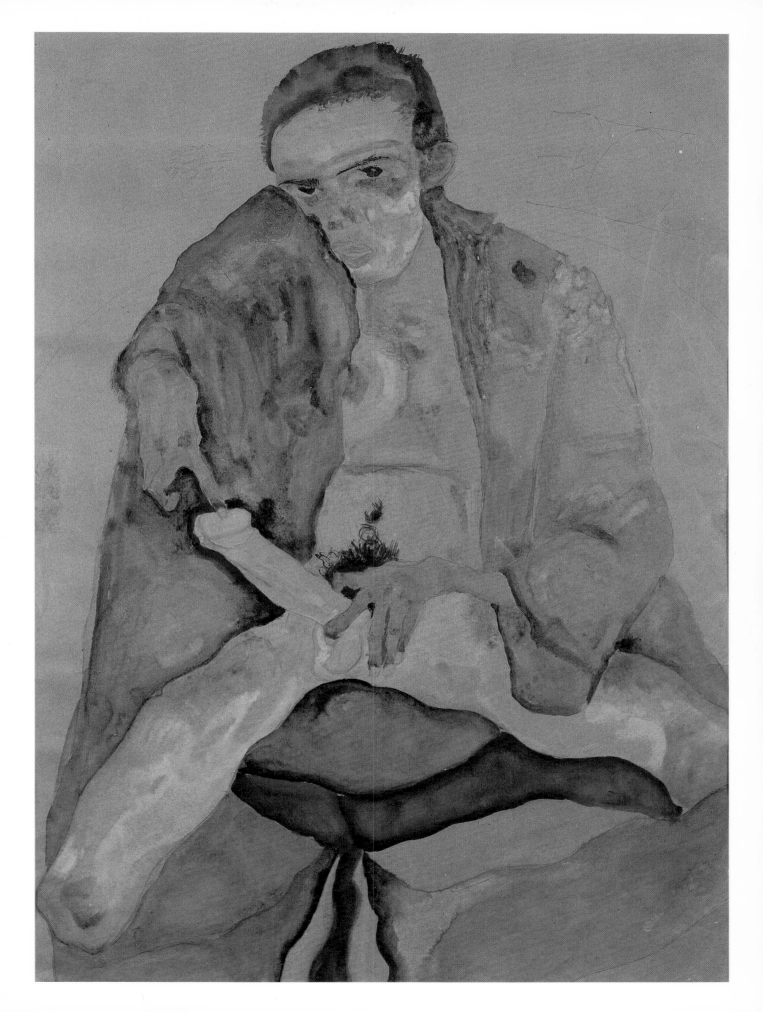

control is lost. The gaunt body, racked by the sexual spasm, powerfully expresses the theme of suffering, and, stretched and limbless as it is, more than hints at the notion of martyrdom. The obsessive sexuality both of Schiele's masturbation self-portraits and of his depictions of the female nude suggests that we are in the presence of a man who, convinced of the futility of human existence, finds meaning only in sex and, crucially of course for Schiele, in the act of expressing this view of life in the permanent form of art.

In addition to their general significance as expressions of sexual *Angst* Schiele's great achievement in these works is to give us, in art of the highest level and quality, an image of an aspect of human behaviour, and a significant aspect, never before treated by artists. He has made more complete and more truthful in terms of behaviour as well as anatomy the image that we present of ourselves in art.

26 (right). *Schiele Drawing a Nude Model before a Mirror*. 1910. Pencil, 55.2 × 35.3 cm. (21¾ × 13⅞ in.) Vienna, Graphische Sammlung Albertina

FEMALE NUDES

Schiele's female nudes require less written commentary or explanation than any of his other works: they have always constituted the best-known and most easily understood aspect of his art. They are un-precedented in great art in their degree of sexual completeness, and

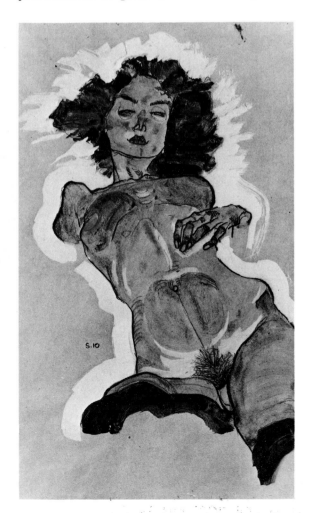

25 (left). *Female Nude*. 1910. Black chalk, watercolour and gouache, white body-colour, 44.3 × 30.6 cm. (17½ × 12 in.) Vienna, Graphische Sammlung Albertina

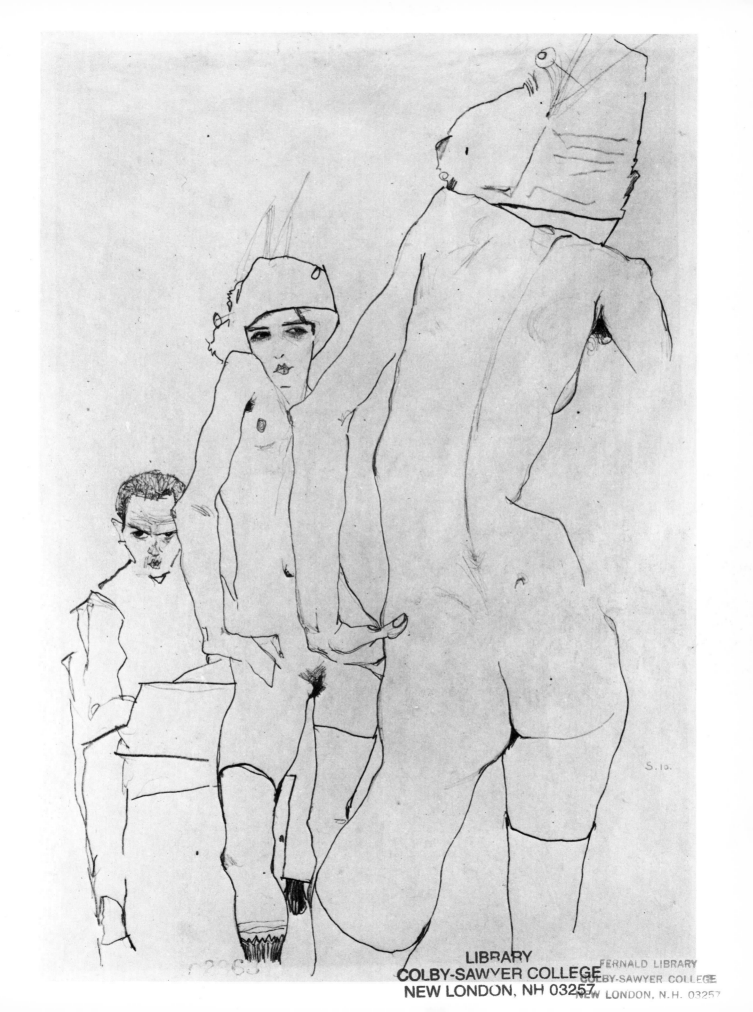

present us in a general way with a view of the human figure which is also new to art. Schiele's female nudes, however, are in no way the vehicle for the expression of metaphysical *Angst* as are that whole group of his male nudes already discussed—they are pure projections of male sexual feeling, and in this respect too they are unprecedented in their range, freedom and intensity.

As we have seen, one of Schiele's earliest nude models, if not the earliest, was his sister Gerti, with whom he seems to have had a degree of sexual complicity. The 1910 nude study of her mentioned earlier (Plate 12) already quivers with the intense power of Schiele's sexual longings, which were at the same time fuelling the self-portraits discussed in the previous section. Already too, and typically of Schiele's female nudes from this time, the focus of the composition, and the major vehicle of expression, is the sexual parts, drawn with obsessional devotion and, in this case, with a strikingly effective expressionist exaggeration of the labia, which are extended downwards and silhouetted sharply against the light ground. The focus on the sexual parts is further emphasized by the simplification of the rest of the composition: distracting details such as the lower legs are cut off, the head is turned away and partly cut off, and even the breasts are hidden.

From the nude study of Gerti and the early 1910 *Seated Nude* (Plate 9) onwards, nudes proliferate in Schiele's *oeuvre*. Even before he formed his relationship with Wally Neuzil in late 1911 he does not in fact seem to have had too much difficulty in finding models to pose nude, and there is a fascinating pencil drawing of 1910 (Plate 26), showing him working from a standing nude model in front of a mirror, that vividly evokes the studio conditions in which his pictures of the nude were produced. Schiele has placed the model so that he can draw first her back view, then her reflected front, and finally his own reflected face squinting in concentration over the drawing block. Every inch of the nervous, bounding line that defines the girl's body is charged with erotic feeling, both pose and facial expression are intensely lascivious and the impact of the drawing is heightened by the extreme closeness, right up on the picture plane, of the model's thrusting buttocks. Indeed, they must have been at eye level and only inches away from Schiele when he drew them.

From 1910 Schiele's vision of woman can be seen as dualistic. The watercolour of a reclining girl (Plate 25) is relatively restrained and represents a type of drawing in which Schiele came as close as perhaps an artist of his temperament could ever hope to get to a celebratory and lyrical treatment of the female nude, to a warm sensuality rather than a harsh eroticism. The genital area is seen simply as pubic hair, the breasts with their beautiful bright orange areolae are softly contoured, and the face is both carefully studied and given an expression of almost sleepy desire. Furthermore, the compositional stress is equally divided among these three elements, giving an unusual quality of balance to the work. *Kneeling Girl Undressing* (Plate 27) is another relatively restrained work of 1910, but later, in 1914, Schiele seems to have found a model who particularly inspired him. He produced a group of drawings of her,

27. *Kneeling Girl Undressing*. 1910. Watercolour, 44.6 × 31 cm. (17½ × 12¼ in.) Courtesy Marlborough Fine Art Ltd., London

110.

#1528.

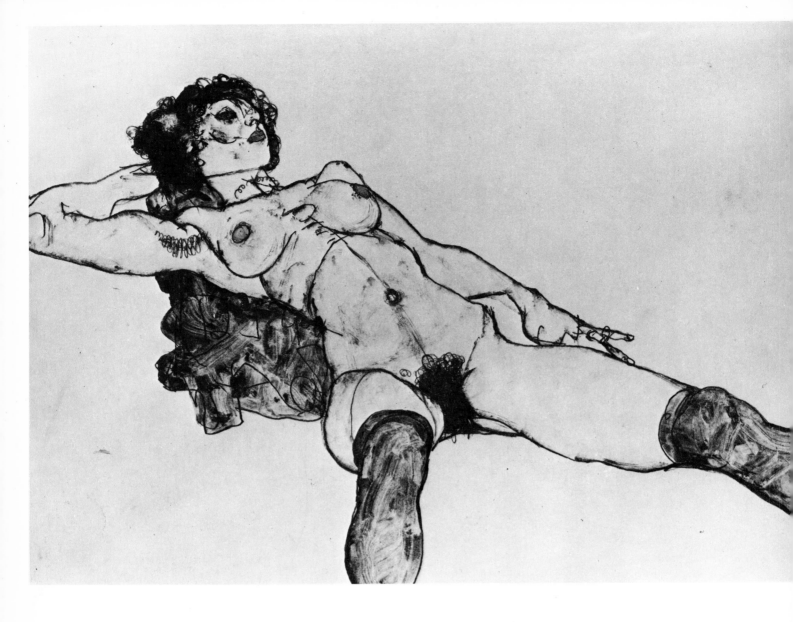

two of which are reproduced here (Plates 28, 73). These must rank among the most formally beautiful and most intensely and lyrically erotic of all his drawings of the single female nude.

The work known as *Red Nude* (Plate 29) is at the opposite pole of sensibility; the balance has gone, the breasts are covered and attention focused on the face, a grotesque leering mask, and the genital area, where Schiele now ruthlessly exposes a pulpy, vivid red vulva. The same red has been applied on the face to the single open eye and the grim mouth, making a clear visual connection of eye, mouth and vulva implying an equivalence of face and genitals. The whole is an image of great, but, it must be said, repellent force: woman as a kind of mindless sexual beast. Another powerful work of this type is *Two Women* of 1911, where attention is drawn even more sharply to the exposed genitals by the fact of the women being otherwise wholly clothed. After 1911, the date of this watercolour, Schiele seems to have mellowed

28 (above). *Recumbent Woman*. 1914. Pencil, gouache, 30.4 × 47.1 cm. (12 × 18½ in.) Vienna, Graphische Sammlung Albertina

29 (right). *Red Nude*. 1910. Pencil and gouache, 56 × 37 cm. (22 × 14⅝ in.) Courtesy Fischer Fine Art Ltd., London

36

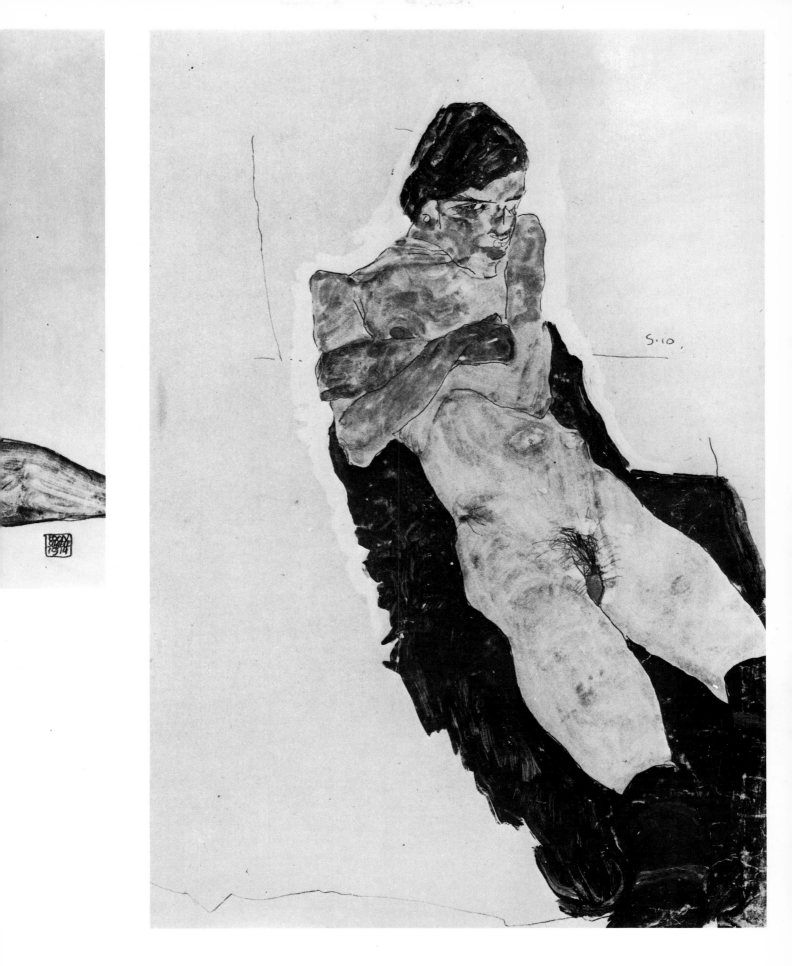

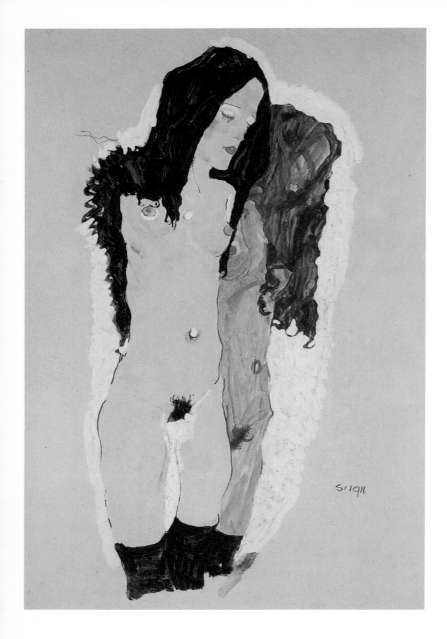

somewhat, and happily quite such an extreme view of woman does not appear again in his work.

Two Women obviously hints at lesbianism, an aspect of female sexual behaviour of great fascination to many men, Schiele among them, and he produced a number of explicit scenes of women making love. *Lovers* of 1911 (Plate 31) is a relatively early work of this kind and one which must be counted among his masterpieces: it combines great beauty of colour and composition with an almost tender evocation of the aftermath of lovemaking—William Blake's 'lineaments of gratified desire'. Plate 30 is another very fine work of this type. Another lesbian scene depicting an earlier and more frenetic stage of lovemaking is the watercolour of 1915 known as *Two Girls Lying Entwined* (Plate 32). The extraordinary composition in which a tangle of bodies and limbs, clothed and unclothed, are welded into a brilliant abstract pattern against the blank ground probably reflects the inspiration of Japanese *shunga* (erotic pictures), which Schiele would certainly have known. Schiele was also fascinated by female masturbation, and, as Klimt had

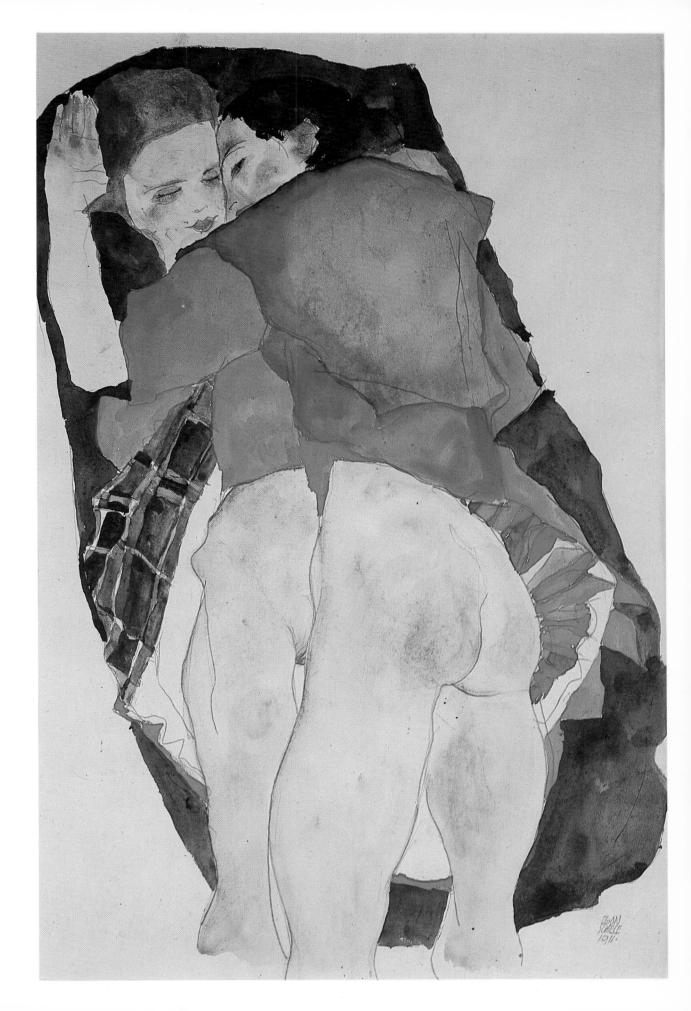

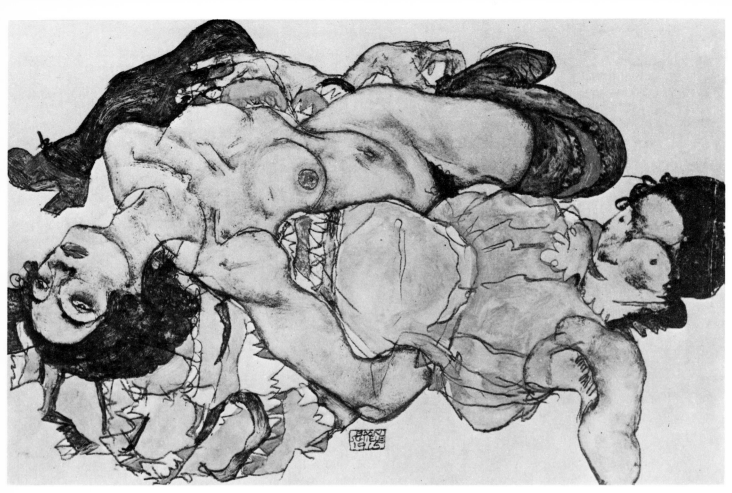

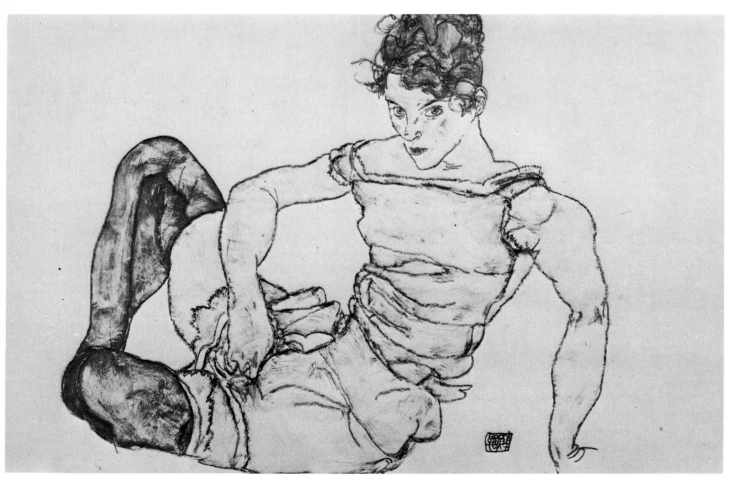

32 (left). *Two Girls Lying Entwined*. 1915. Pencil, gouache, 32.8 × 49.7 cm. (12⅞ × 19⅝ in,) Vienna, Graphische Sammlung Albertina

33 (left). *Seated Woman with Violet Stockings*. 1917. Tempera and black chalk, 20.9 × 40.4 cm. (8¼ × 15⅞ in.) Courtesy Fischer Fine Art Ltd., London

34 (right). *Girl in a Blue Dress*. 1911. Watercolour. Private collection

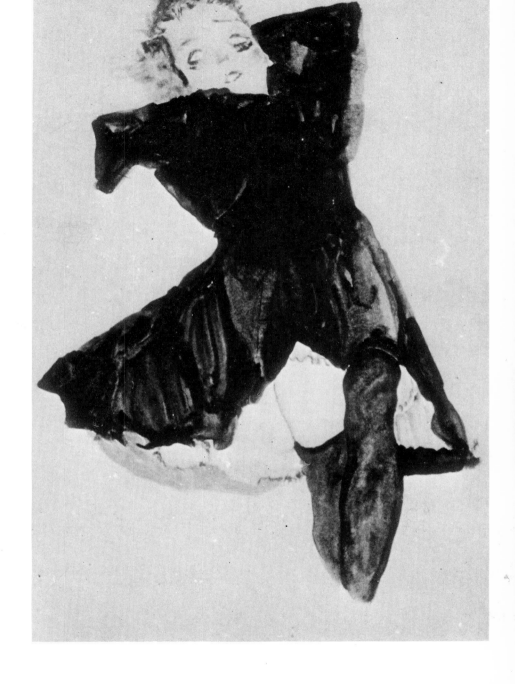

before him, depicted it in his work (Plate 33). Two other aspects of his view of woman can be seen in Plates 34 and 35.

Schiele produced relatively few major oil paintings of the female nude, and, as we have seen, at least two of those few are lost. One that has survived is the 1917 *Reclining Woman* (Plate 36) which now remains his most important statement in oils of this theme.

35. *Nude with Violet Stockings*.
1910. Watercolour, 45 × 31 cm.
(17¾ × 12¼ in.) Private collection

36. *Reclining Woman*. 1917. Oil
on canvas, 96 × 171 cm.
(37¾ × 67⅜ in.) Private collection

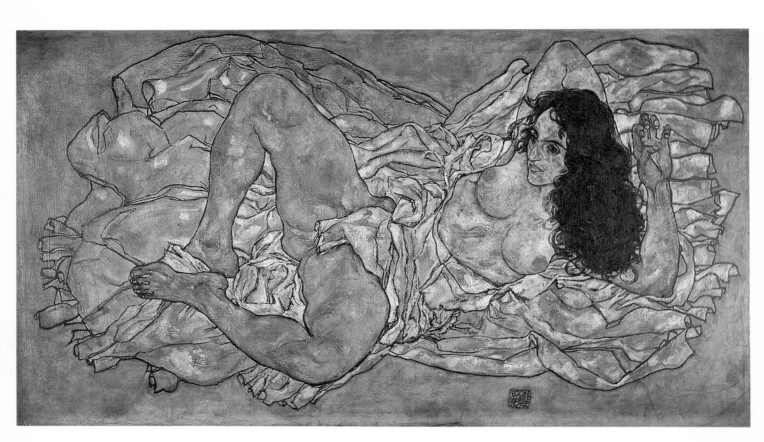

The works discussed in this section are among those by Schiele which have been referred to earlier in the text as allegories, that is they are works dealing with some of the great general recurrent themes of human art, procreation, birth and death. In Schiele's art these themes frequently overlap each other, and some of his allegorical works appear to use them in addition as a means of commenting on the relationship of the artist to society. These will be discussed in that context in the next section.

Schiele's allegories are all oil paintings and tend to be on a larger scale than any of his other works. This is an index of the importance he attached to them and reveals his awareness that in them above all he was giving a distinctively modern form to the great tradition of European art. It is undoubtedly on his allegories that Schiele would have wished his reputation to rest.

They are indeed remarkable, especially that group, which can be seen as constituting a core, dealing with the twin obsessions of procreation and death. Of these there is a particularly important subgroup in which those two themes are brought together to create an allegory of the entire

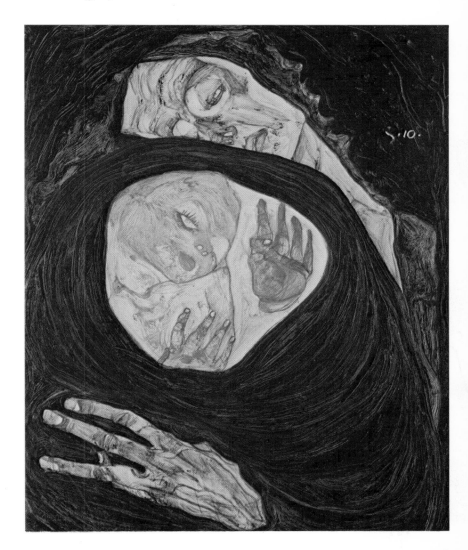

37. *Dead Mother*. 1910. Oil on wood, 32 × 25.7 cm. (12⅝ × 10⅛ in.) Private collection

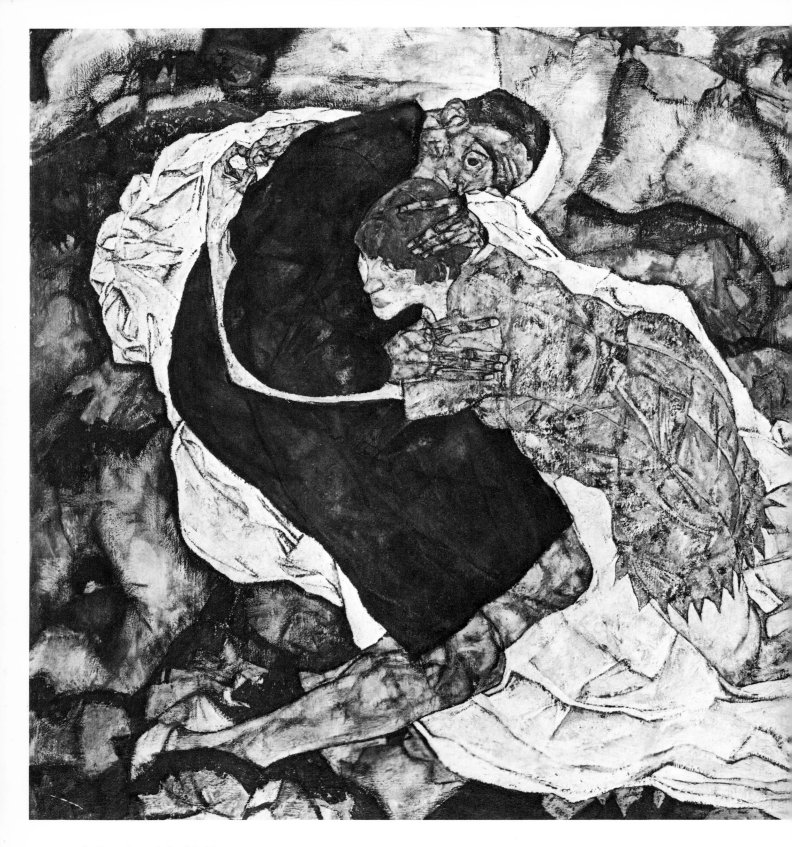

38. *Death and the Maiden*. 1915.
Oil on canvas, 150·5 × 180 cm.
(59¼ × 70⅞ in.) Vienna,
Österreichische Galerie

44

human life cycle. The earliest and among the most powerful and original of these is the *Dead Mother* of 1910 (Plate 37). Here Schiele has brilliantly formalized the folds of the cloak around the baby so as to suggest a womb swelling with the new life within. The embryonic effect is enhanced by the way in which vividly pulsing blood is seen beneath the translucent skin of the child. The contrast with the mother is stark and again brilliantly contrived: immediately above the child's face looms that of its dead parent, gaunt, bloodless, already almost skull-like, while below a skeletal hand appears still clasping the baby, even in death.

A year later Schiele painted a second version of this subject, *Dead Mother II*, which he subtitled *The Birth of Genius*. Beyond their general theme these works almost certainly have an autobiographical significance. The Viennese art critic Arthur Roessler has recorded in his *Memoirs* that after Schiele had complained of his mother's unsympathetic treatment, he suggested to Schiele a series of paintings on aspects of motherhood. Schiele painted *Dead Mother I* almost immediately, and it can possibly be read as an extreme statement of his feelings about his own mother. Whether or not this is really the case, clearly Schiele's emotions were strongly engaged with his subject, and it is this autobiographical element, always very much present in his allegories, that enabled him so successfully to invest traditional and general themes with a new power and intensity.

Alessandra Comini sees the second dead mother painting, *The Birth of Genius*, also as having a specific autobiographical meaning, the genius of the title being Schiele himself, and she quotes a remarkable letter from him to his mother in which he says, 'Without doubt I shall be the greatest, the most beautiful, the most valuable, the purest and the most precious fruit. Through my independent will all beautiful and noble effects are united in me . . . I shall be the fruit which after its decay will still leave behind eternal life; therefore how great must be your joy—to have borne me?'

The sublime egotism of this may shed light on another variation on the theme of birth and death, the *Pregnant Woman and Death* of 1911 (Plate 39). Both the monk representing death and the pregnant woman are quite clearly self-portraits, and it is difficult to avoid the conclusion that Schiele is here appearing as the be-all and end-all, as both giver and taker of life, the Creator himself.

A further and later painting of the subject of woman and death is *Death and the Maiden* of 1915 (Plate 38), one of Schiele's undoubted masterpieces. In fact, although on the face of it this picture belongs in a long tradition of life-cycle pictures of death and the maiden, it appears above all as a strikingly poignant evocation of the notion of death as a final parting of lovers. Again the emotional force of this painting has almost certainly an autobiographical basis: the male figure is a self-portrait and the female figure has been firmly identified as a portrait of Schiele's mistress Wally Neuzil. By the time the picture was painted in the spring of 1915 Schiele had met and fallen in love with a girl called Edith Harms and was on the brink of marriage to her (they married on

17 June 1915). Wally, who seems to have remained faithful to Schiele, was an increasing embarrassment to him. *Death and the Maiden* can be seen as his tribute and farewell gesture to her, and as such, it may be added, its magnificence is entirely appropriate.

In 1913 Schiele painted a *Holy Family* (Plate 40), which appears to mark the start of a series of works dealing with motherhood and the family without the element of death. The male figure is a self-portrait, and this is one of the paintings like *Pregnant Woman and Death*, in which Schiele depicts himself as monk or saint. The form containing the baby, at the focus of the composition, is borrowed from the earlier *Dead Mother* but here it is painted a vivid bloodshot orange-yellow that

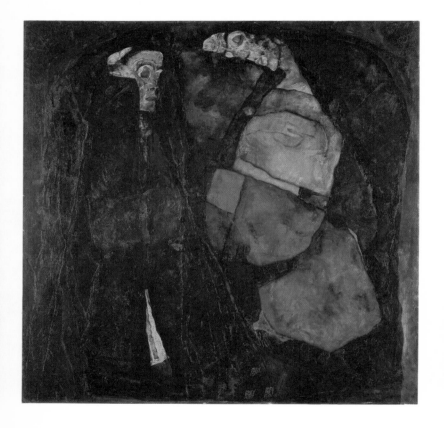

40 (below). *Holy Family.* 1913. Pencil and gouache on transparent paper, 47 × 36.5 cm. (18½ × 14⅜ in.) Private collection

39 (above). *Pregnant Woman and Death.* 1911. Oil on canvas, 100.5 × 100.5 cm (39⅝ × 39⅝ in.) Prague, Národní Galerie

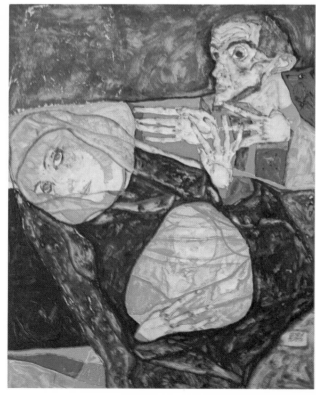

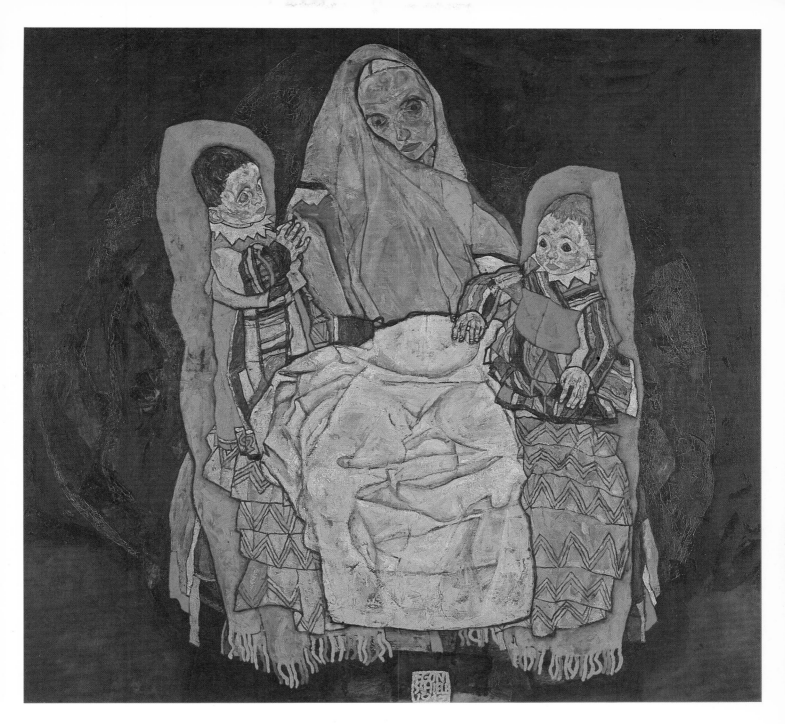

41. *Mother with Children.*
1915–17. Oil on canvas,
150 × 159 cm. (59 × 62⅝ in.)
Vienna, Österreichische Galerie

irresistibly evokes a fertile egg yolk at an early stage of its development.

Schiele pursued the motherhood and family theme right to the end of his life in works such as *Blind Mother* and *Young Mother*, both of 1914, the great *Mother with Children* of 1915–17 (Plate 41) and *The Family* of 1918 (Plate 42).

Mother with Children is an outstanding example of Schiele's ability to make pictures in which highly expressive figurative elements are perfectly integrated into an essentially abstract, and in this case very beautiful, overall structure of colour, form and texture. The power of this painting comes particularly from Schiele's reintroduction of the element of death and from the way he has contrasted the two children, their faces set like jewels in their gaily patterned clothing, with the

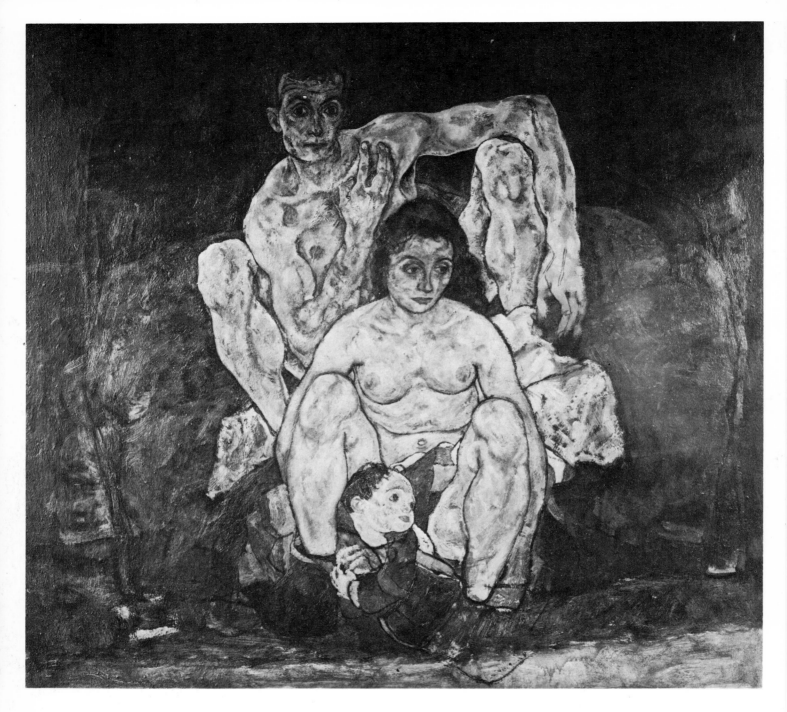

deathly face of their mother. It is not only a picture of motherhood but yet another variation of the cycle of life. *The Family* remained unfinished at Schiele's death. The male figure is a remarkably direct self-portrait, and the whole treatment is strikingly naturalistic compared to the *Mother with Children*. The female figure, however, is not his wife but a model.

As a counterpart to the paintings purely of motherhood and family there is at least one painting dealing with death. This is *Self-Observer II (Death and Man)* of 1911 (Plate 43). However, it is also one of three double self-portraits done in 1910 and 1911 with which can be grouped too the self-portrait known as *Lyricist* or *The Poet* of 1911. All of these works reflect Schiele's deep preoccupation with the self, and once again

42. *The Family*. 1918. Oil on canvas, 152.5 × 162.5 cm. (60 × 64 in.) Vienna, Österreichische Galerie

in *Death and Man* we find the force of the artist's own psychological obsessions giving new power to a traditional theme. Schiele's broad concern in these works is with the dualism of human nature, something he seems to have been particularly strongly conscious of, and in *Death and Man* he seems to be suggesting that death is something we carry with us always, an integral part of our psyche: the figure of death bears Schiele's own features, skull-like but unmistakable, and its ectoplasmic form seems to be emerging from his, or perhaps merging back into it. It need only be added that about ten years after this work was painted

43. *Self-Observer II (Death and Man)*. 1911. Oil on canvas, 80.5 × 80 cm. (31¾ × 31½ in.) Private collection, Switzerland

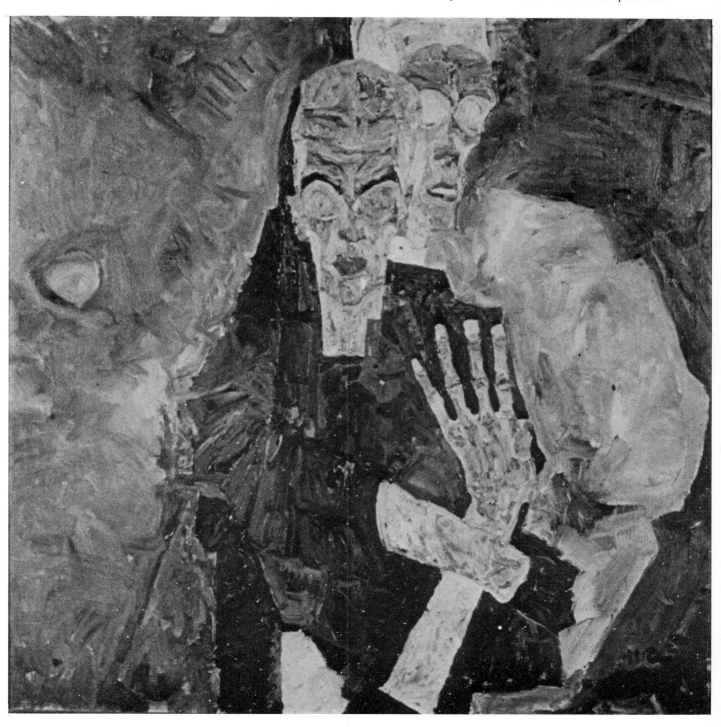

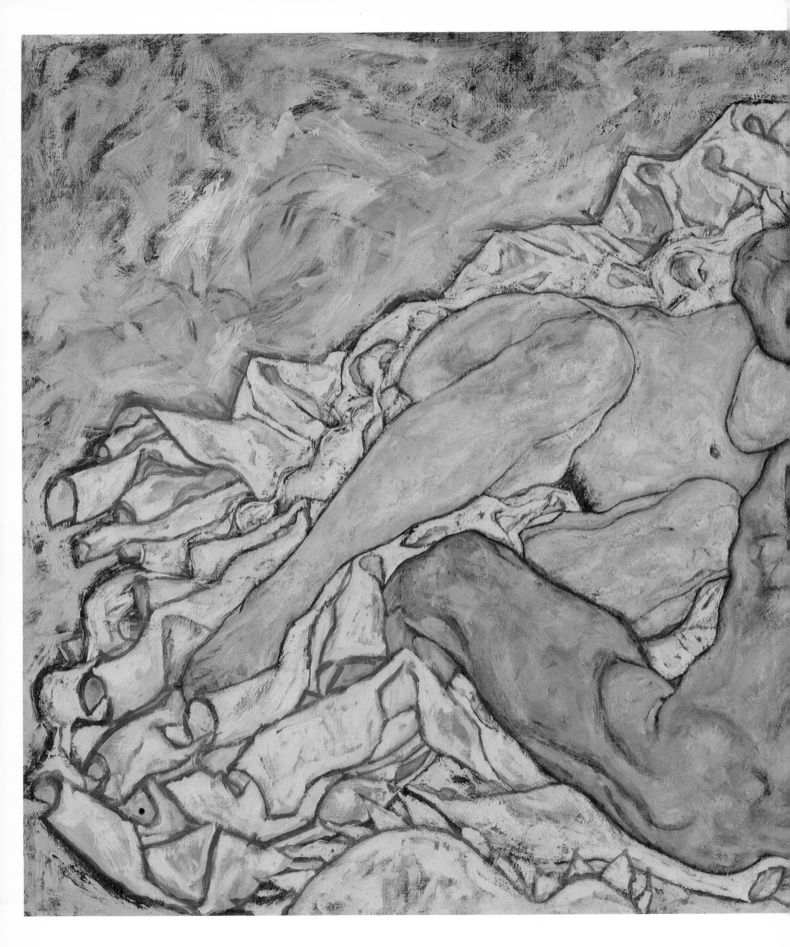

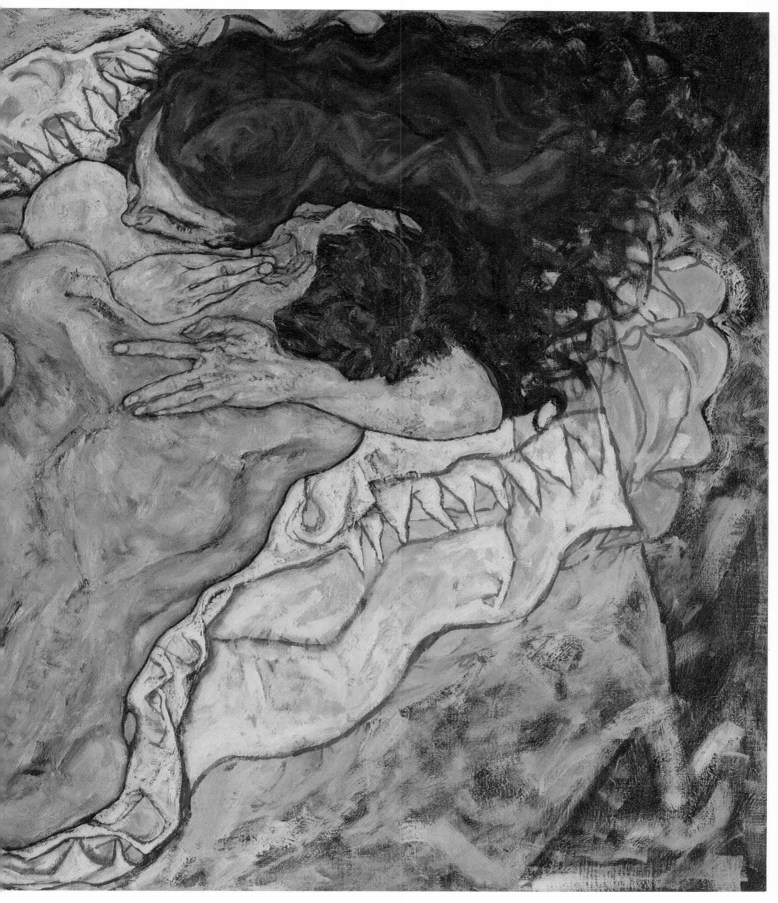

44. *Embrace.* 1917. Oil on canvas,
110 × 170 cm. (43¾ × 66⅞ in.)
Vienna, Österreichische Galerie

Sigmund Freud published *Beyond the Pleasure Principle*, in which he put forward for the first time his theory that man does indeed possess a death instinct as well as the life instinct, or Eros, and that these two instincts dominate in parallel the unconscious mind.

Not surprisingly, perhaps, in view of his strong sense of mortality, Schiele had a penchant for deathbed sketches. Those he made of Gustav Klimt have already been mentioned. As his wife lay dying of 'flu in October 1918, just three days before Schiele himself succumbed to the same disease he sketched her for the last time.

Finally in this section we must consider Schiele's representations of love itself, of the heterosexual act. These are relatively rare in his art and are mostly in watercolour. Some of them, like the 1913 and 1915 representations of himself and his wife Edith (Plates 45, 46), have a degree of autobiographical specificity which keeps them below the level of the allegories. Some, however, like the ravishing and lyrical *Lovers* (Plate 47), are masterpieces, and in 1917 Schiele did paint one marvellous oil, known as *Embrace* (Plate 44), which remains one of the great images in art of human sexual love.

46 (right). *Seated Couple*. 1915. Pencil, gouache, 52 × 41.1 cm. (20½ × 16⅛ in.) Vienna, Graphische Sammlung Albertina

45 (below). *Embrace*. 1913. Watercolour. Private collection

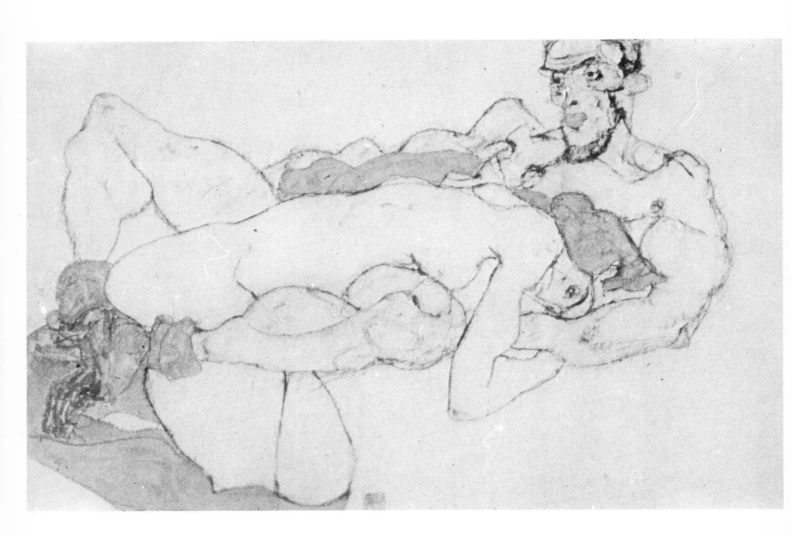

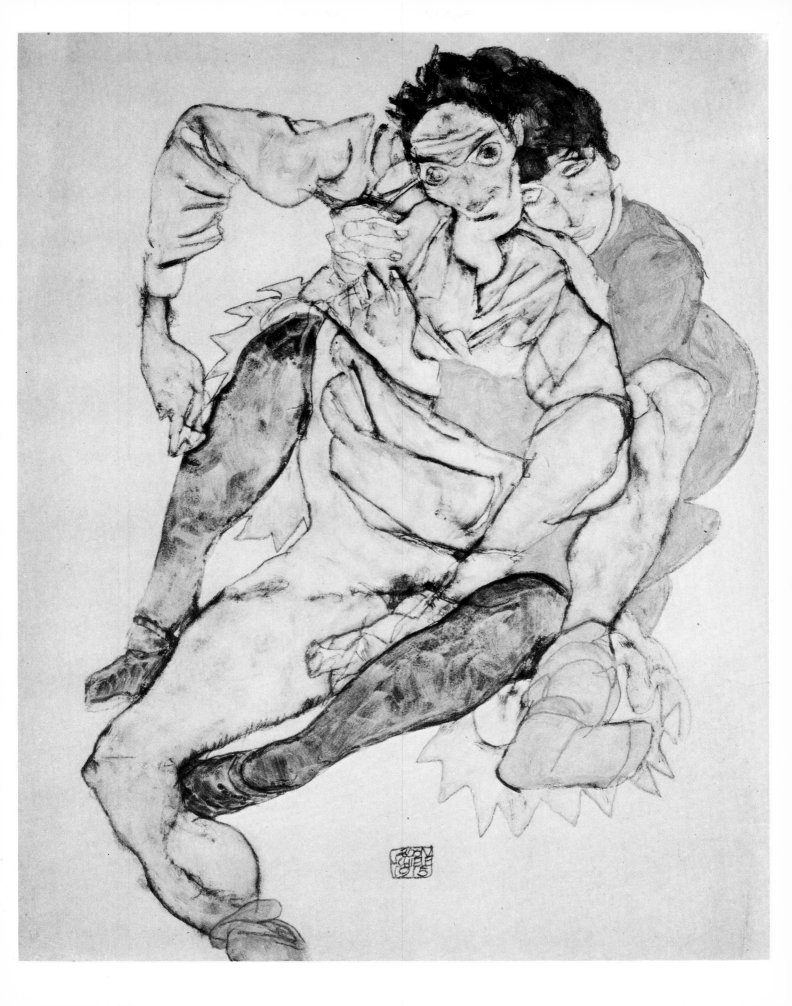

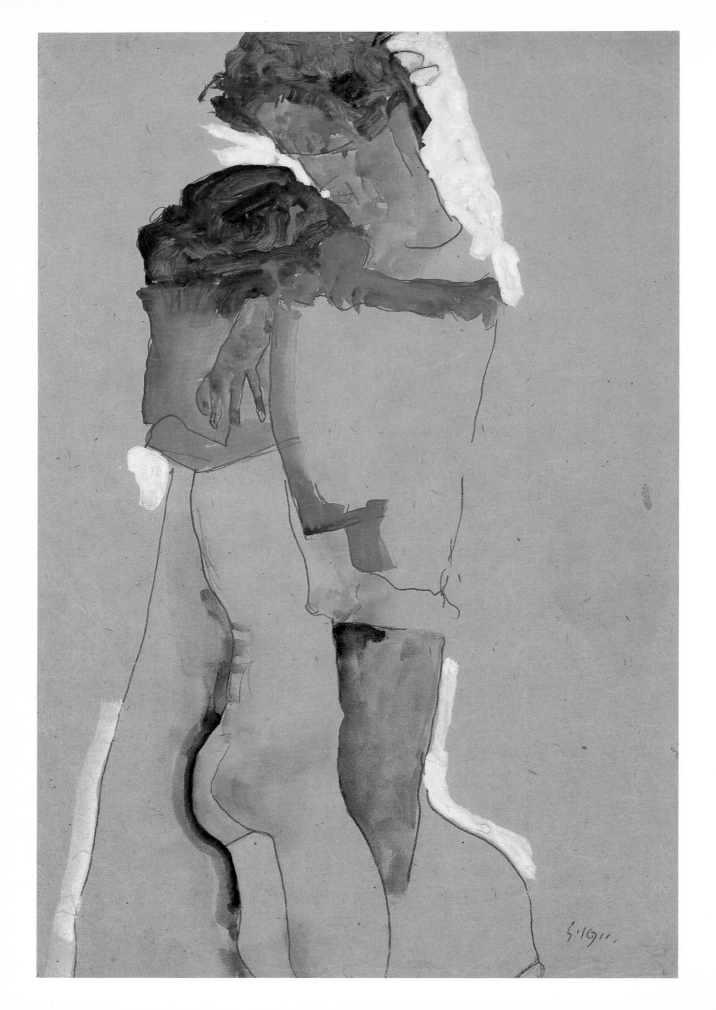

47 (left). *Lovers.* 1911. Gouache.
Private collection

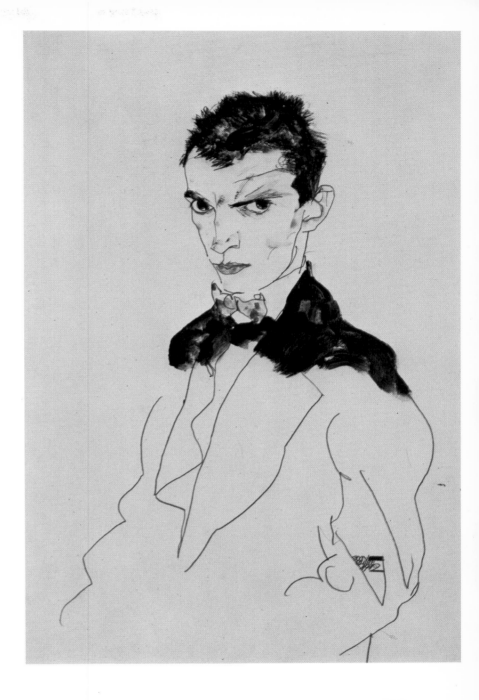

THE ARTIST AND SOCIETY

The beginnings of modern art have already been very briefly outlined
above (p. 10). The changes in subject-matter and approach that took
place in European art from the late eighteenth century meant also that
the conditions of patronage began to change with increasing rapidity.
To put it very simply, great artists became less and less concerned with
fulfilling the tastes and demands of patrons and more and more con-
cerned with creating art which was the expression of their personal
ideas and visions. This of course led them into difficulties of a kind
strikingly illustrated in, for example, the careers of the two very
different English artists, William Blake (1757–1827) and John Constable
(1776–1837). Neither of these artists found either a wide market or any
significant degree of critical appreciation in their lifetime although both
are now accepted as geniuses. A gap thus opened up between the artist

48. *Self-Portrait.* 1912. Pencil,
watercolour, gouache,
46.5 × 31.5 cm. (18¼ × 12⅜ in.)
Private collection

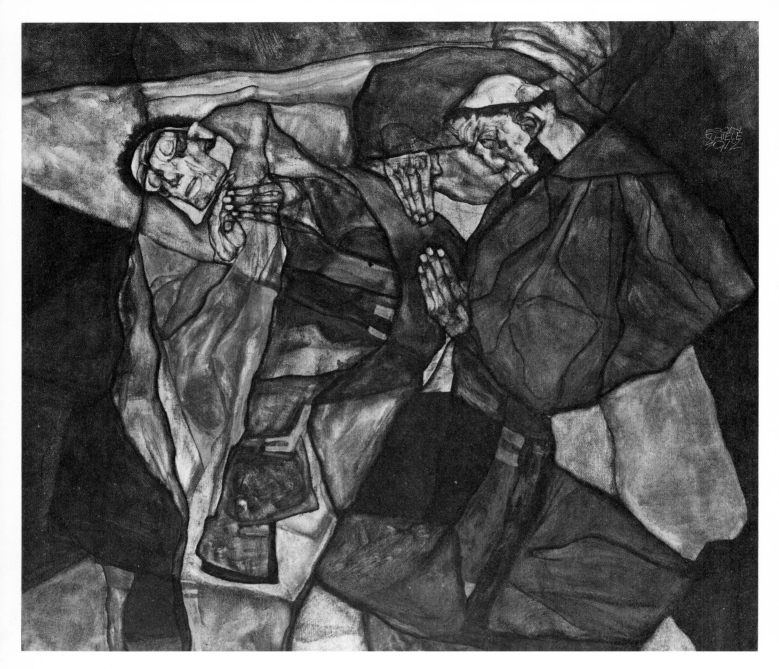

and society, a gap which was often *moral* as well as aesthetic: both Constable and Blake in their different ways implied in their art a critique of the world in which they lived. Egon Schiele was a twentieth-century heir to this tradition, which by his time had produced at least one prominent martyr, much admired by Schiele, Vincent Van Gogh, who shot himself in 1890, having sold only a single painting in his life.

Schiele, as has been mentioned above, was intensely conscious of the peculiar status of the artist in society, and like many of his predecessors, he was also baffled, bewildered, embittered and angered by society's reciprocal indifference or even, on occasion, outright hostility. In a letter of January 1911 to his friend the critic Roessler he concluded a long tirade about his poverty and neglect by dealers and patrons with the words, 'I am extremely sensitive, and all these people have absolutely no idea how they should behave towards an artist.' Then, in the diary he kept during his imprisonment in Neulengbach in 1912, he

49. *Agony.* 1912. Oil on canvas, 70 × 80 cm. (27½ × 31½ in.) Munich, Bayerische Staatsgemäldesammlungen, Neue Pinakothek

wrote on 24 April: 'Not very far from me, so near that he would have to hear my voice if I were to shout, there sits in his magistrate's office a judge, or whatever he is. A man, that is, who believes he is something special, who has studied, who has lived in the city, who has visited churches, museums, theatres, concerts, yes, probably even art exhibitions. A man who consequently is numbered among the educated class which has read or at least heard of the life of the artist. And this man can permit me to be locked in a cage!'

Schiele's sense of the alienation and special status of the artist found one expression in his life in a personal dandyism. Dandyism was a mode of behaviour adopted by many artists, poets and writers in the nineteenth and early twentieth centuries. It was in essence a means for the artist to become himself a work of art, an embodiment of the artistic values by which he lived and, of course, to advertise his apartness from those whose lack of sensibility led them to dress, and to live, merely for utilitarian purposes.

Schiele's dandyism is already very marked in the great self-portrait of 1909 (Plate 11). In spite of its partial nudity it conveys immense elegance, and the head is both romantically handsome and expressive of great sensibility. Schiele was in fact a foppish dresser, even when hard up, and designed his own clothes. A self-portrait drawing of 1912, somewhat in the style of a fashion plate, showing him in high-collared shirt, bow tie and elegantly cut jacket, probably gives a good idea of his day-to-day appearance (Plate 48).

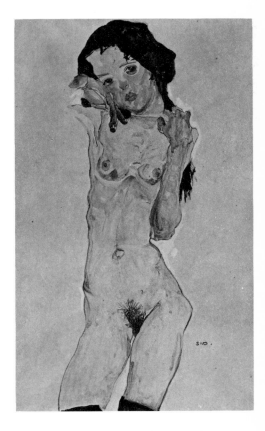

50. *Nude Black-Haired Girl.* 1910. Pencil, watercolour, gouache. Vienna, Graphische Sammlung Albertina

The painting which is known as *The Poet* is closely related to the *Angst*-ridden self-portraits of 1910–11 and indeed is one of Schiele's early masterpieces of Expressionist painting. It has unfortunately proved impossible to obtain a reproduction here, but its title strongly suggests that in it Schiele's anguished vision of man is being used to make a statement specifically about the condition of the artist, condemned, by his greater sensitivity and visionary ability, to see the reality behind appearances and to suffer more intensely than his fellow men, and because of this to suffer alienation from them. A notable feature of this painting is the ambiguous treatment of the pubic region, which appears female in character with a red-tipped phallic form thrusting into it from the lower edge of the canvas. This ambiguity is not an isolated phenomenon in Schiele's art, for there are a number of other self-portraits in which he apparently depicts himself with female sexual parts: for example the self-portrait, Plate 23, where the hands cover the male genitals to create images of the female ones. A full explanation of this is probably impossible without launching into the wilder realms of sexual psychology, but two suggestions can be made. Firstly, there is an obvious connection with the image of himself as a pregnant woman in *Pregnant Woman and Death* (Plate 39), the genital ambiguity perhaps reflecting his view of the artist as universal creator. Secondly, Schiele in these self-portraits is producing, consciously or unconsciously, an Expressionist reworking of that very common feature of Symbolist art, the androgyne, a creature produced by feminizing a basically male form. With Schiele the androgyne has a dual significance:

it is a mythical or ideal being beyond ordinary humanity, but also has its counterpart in real life in the transexual and the feminine homosexual, both outside the norms of society and to some extent misunderstood or persecuted. Schiele's adoption of an androgynous image can be seen therefore as another expression of his sense of specialness, apartness and alienation. This view found its fullest, and in formal and pictorial terms greatest, realization in the 1912 painting *The Hermits*, in which Schiele depicted himself and Klimt as wandering outcasts, ascetics and prophets condemned to the desert, voices 'crying in the wilderness'. *Agony* (Plate 49) is a second version of this subject (probably done at the request of a patron who had admired the first), whose title makes an additional comment.

Schiele's arrest and imprisonment in 1912 were fundamentally the result of the open sexuality of some of his art combined with the sexual unconventionality of his life-style, which was especially conspicuous in the small town of Neulengbach. The alienation of the modern artist is obviously exacerbated if, like Schiele, he chooses to deal openly with sex in his art in a social world where such openness arouses intense

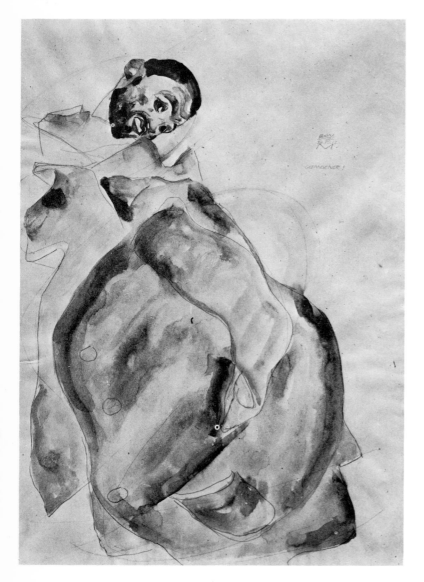

51. *Prisoner!* 24th April 1912.
Pencil and watercolour,
31.7 × 48.7 cm. (12½ × 19⅛ in.)
Vienna, Graphische Sammlung
Albertina

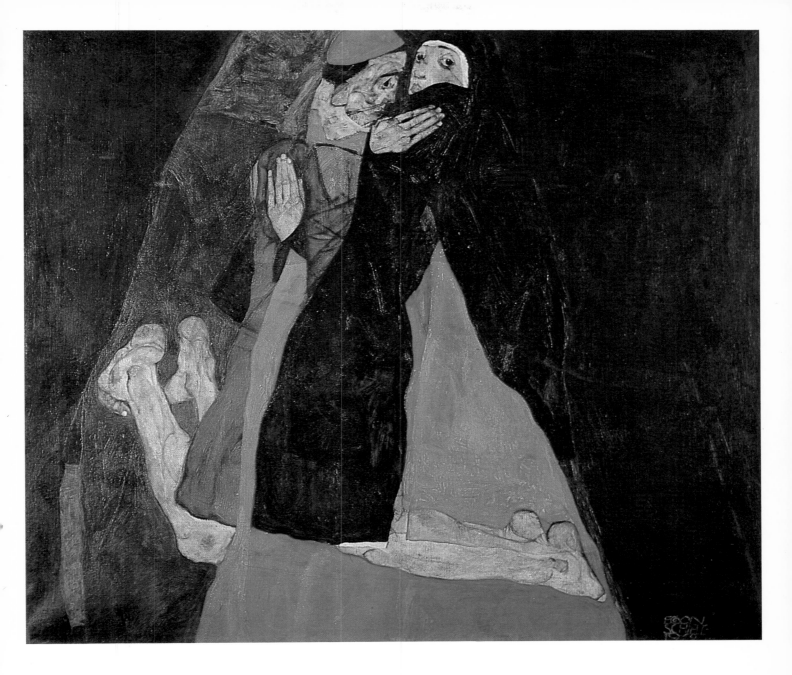

52. *Cardinal and Nun*. 1912. Oil
on canvas, 70 × 80.5 cm.
($27\frac{1}{2}$ × $31\frac{3}{4}$ in.) Private collection

anxiety and hostility. In particular he seems to have alarmed Neuleng-
bach by inviting village children to pose for him – not in the nude,
apparently, although in the past he had drawn quite young girls nude
(Plate 50). The basic facts of this episode have already been mentioned;
full details of the events which led to his trial, together with the text of
his prison diary, can be found in Alessandra Comini's *Egon Schiele in
Prison* and need not be repeated here.

Among the numerous aspects of his situation which tortured Schiele
in his first days in prison was his lack of the means to write and make
art. When these were finally allowed him, after three days, he began his
prison diary: 'At last! At last! At last! At last alleviation of pain! At last
paper, pencils, brush, colours for drawing and writing. Excruciating
were those wild, confused, crude, those unchanging, uniformed,
monotonously grey, grey hours which I had to pass—robbed, naked,
between cold bare walls—like an animal.' Once he had these materials

Schiele was once again able to transcend his suffering by transforming it into art. All Schiele's prison watercolours are inscribed with aphoristic comments one of which, 'Art cannot be modern, art is eternal,' has already been quoted. This, rather oddly, occurs on a tenderly objective little watercolour of two chairs, which is one of a group of such depictions Schiele made of his cell, its contents and the interior of the prison. Apart from these the prison watercolours comprise a group of self-portraits in which Schiele appears as the archetypal prisoner and victim, crop-headed, gaunt-faced and huddled protectively into coats and blankets so that only the head with its staring, suffering eyes appears. These works and their captions speak for themselves of Schiele's emotions and of his reaction to society's act in imprisoning him. Three of them in particular encapsulate the range of his response: *Prisoner!* (Plate 51); *Hindering the Artist is a Crime, It is Murdering Life in the Bud!* (Plate 53) and *For My Art and for My Loved Ones I Will Gladly Endure to the End!* (Plate 54).

After his release Schiele produced the oil painting *Cardinal and Nun* (Plate 52), which has usually been seen as a blasphemously satirical attack on the moral agency which was ultimately responsible for his imprisonment. Somewhat later, in 1913, he also produced a nude self-

53 (below left). *Hindering the Artist is a Crime, It is Murdering Life in the Bud!* 23rd April 1912. Pencil and watercolour. Vienna, Graphische Sammlung Albertina

54 (below right). *For My Art and for My Loved Ones I Will Gladly Endure to the End!* 25th April 1912. Pencil and watercolour, 48.2 × 29.5 cm. (19 × 11⅝ in.) Vienna, Graphische Sammlung Albertina

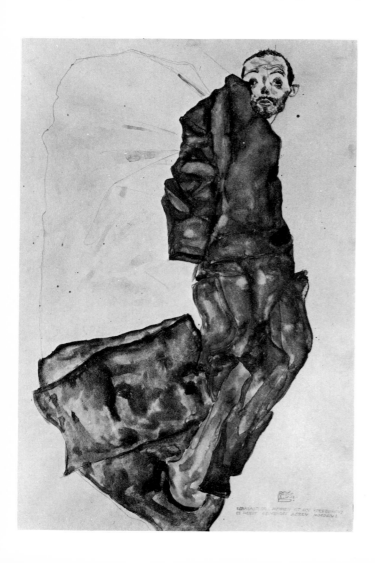

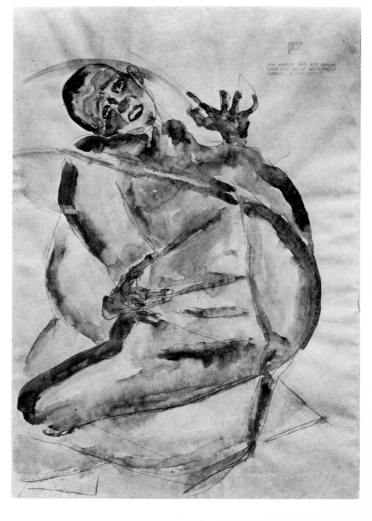

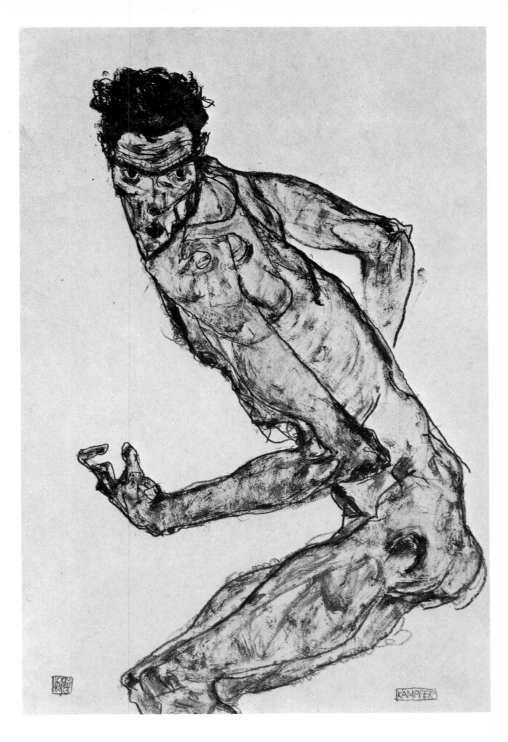

55. *Fighter*. 1913. Pencil and
gouache, 48.7 × 32.1 cm
(19⅛ × 12⅝ in.) Private collection

portrait watercolour inscribed with the single word *Kämpfer*—
fighter—which is a powerful image of continuing defiance. The artist,
his body rippling with muscle, is crouched like a beast at bay ready to
spring at his aggressors (Plate 55).

The image of himself as ascetic or saint which had already appeared
in the 1911 *Pregnant Woman and Death* and in the self-portraits with
Klimt took on a new relevance in the aftermath of his imprisonment,
reappearing in works such as the 1913 *Holy Family* (Plate 40), the major
oil painting *Levitation* of 1915, and, most vividly, in the *Self-Portrait as
Saint Sebastian* (Frontispiece), already discussed. There is also a lost
painting of 1913, *Self-Portrait with Saint (Encounter)*.

LANDSCAPE AND TOWNSCAPE

The painting of nature and the recording of the man-made environments in which he found himself played an important if subsidiary role in Schiele's art throughout his life. His landscapes and townscapes, his paintings of flowers and trees, his interiors and still-lifes provide a crucial element of balance in the overall pattern of his *oeuvre*. For Schiele himself, as has already been suggested, they probably acted as a

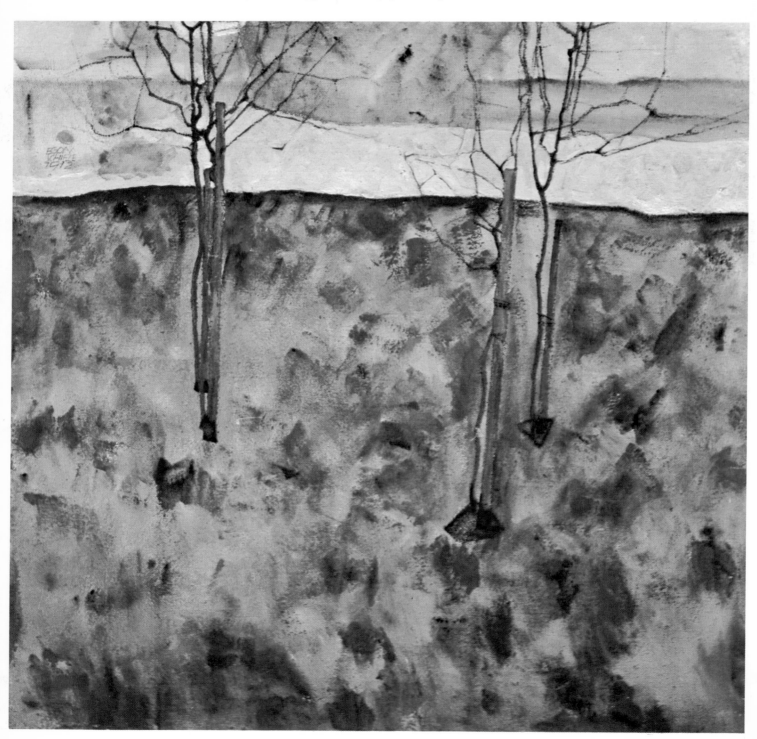

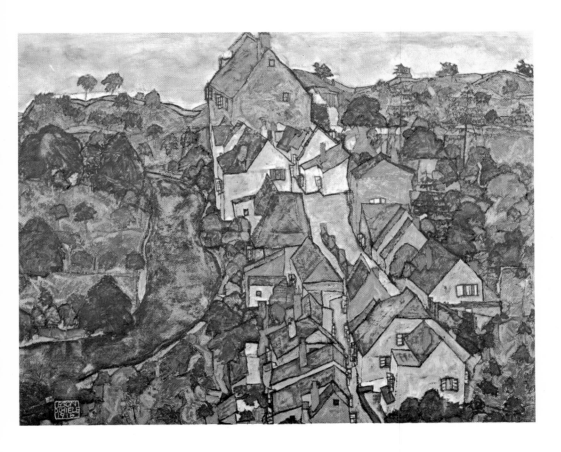

57 (above). *Landscape at Krumau*. 1916. Oil on canvas, 110 × 140.5 cm. (43¼ × 55¼ in.) Linz, Neue Galerie, Wolfgang Gurlitt Museum

58 (right). *Sunflower*. 1909–10. Oil on canvas, 149.5 × 30 cm. (58⅞ × 11⅞ in.) Vienna, Historisches Museum der Stadt Wien

56 (left). *Winter Trees*. 1912. Oil on canvas, 80.5 × 80.5 cm. (31¾ × 31¾ in.) Private collection

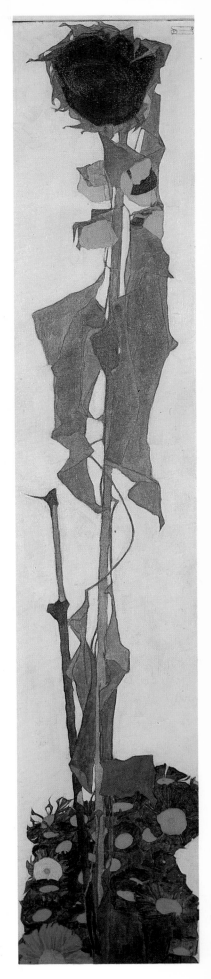

necessary relief from the stress of his work with the human figure. They were the outcome of a response to nature and to certain aspects of the human environment that was always authentic, strong and lyrical: at the age of twenty he wrote, 'I received the clearly remembered impressions of my childhood from flat countrysides with tree-shaded spring-time roads and raging storms. In those days it seemed to me as though I already heard and smelled the miraculous flowers, the speechless gardens, the birds in whose shiny eyes I saw my rosy mirror image. Often when it was autumn I wept with half-closed eyes. When it was spring I dreamed of the universal music of life, then I rejoiced in

60 (right). *Field of Flowers*. 1910. Black chalk, gouache, gold bronze paint on paper, 44.5 × 30.8 cm. (17½ × 12⅛ in.) Private collection

59 (below). *Church on the Danube*. 1913. Oil on wood, 39.8 × 31.6 cm. (15⅝ × 12½ in.) Private collection

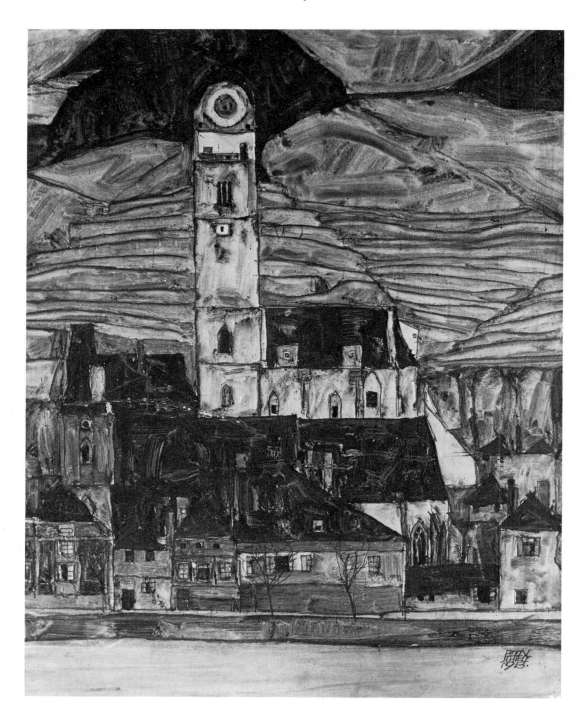

the magnificent summer and laughed as during its splendour I painted for myself the white winter.' Two years later in his prison diary he described his transfer by train to another prison: 'It was a slow train, which pleased me this time, because I wanted to see a great deal and for a long time. I saw beautiful things: sky, clouds, flying birds, growing trees and quiet houses with cushion-soft roofs.' Later, back in prison, he wrote one day, 'How long is it now that I have seen no soft cotton clouds, no dewy mornings, no blue twilight evenings, only black, black night?'

Two early pictures of 'miraculous flowers' are the *Sunflower* of 1909–10, a substantial oil (Plate 58), and the *Field of Flowers* of 1910, a gouache (Plate 60). *Sunflower* must be ranked among the Symbolist masterpieces of Schiele's first maturity, a work of powerful design, intense decorative effect and universal significance as an emblem of the cycle of life: the great leaves, formalized into striking patterns of autumnal brown and green against the white ground, droop in death while above and below the bursting seed-head and the late marigolds symbolize fruitfulness and the new life to come. *Field of Flowers* is more directly naturalistic, a vivid and joyous expression of an immediate and uncomplicated response to nature.

Schiele's mature landscape art, like his figure pictures, is a blend of naturalism with varying degrees of formalization and expressionist stylization. In *Winter Trees* of 1912 (Plate 56) the bleak landscape of bare soil, snow and fragile skeletal trees has been reduced to an almost abstract arrangement of tone and line. In the 1916 *Landscape at Krumau* (Plate 57) Schiele creates a vivid pattern of form and colour which yet incorporates considerable topographical detail. This marvellous painting, with its delicious pink, green and orange colour composition, is an outstanding example of the warmth of Schiele's response to the domestic architecture of this picturesque old town, and especially to those symbols of security, 'the cushion-soft roofs'.

PORTRAITS

Portrait painting, particularly when done on commission, can often lead or force an artist to compromise with his true style and vision. With the possible exception of certain commissions from the very end of his life this is never the case with Schiele. His portraits are an absolutely integral part of his total *oeuvre*: among them indeed are to be found some of his very highest achievements.

The uncompromising nature of Schiele's approach to portrait commissions is apparent from very early on. In 1910 he received his most important commission from the Wiener Werkstätte; for a portrait of a young girl, Poldi Lodzinsky. This was to be used as the basis of a stained glass window in the Stoclet Palace being built and decorated by the Wiener Werkstätte in Brussels. Not surprisingly, perhaps, the finished portrait (Plate 63) was rejected: he has given this child a facial expression of almost leering sexual knowingness, he has grotesquely

61. *Portrait of Arthur Roessler*. 1910. Oil on canvas, 99.5 × 100 cm. (39⅛ × 39⅜ in.) Vienna, Historisches Museum der Stadt Wien

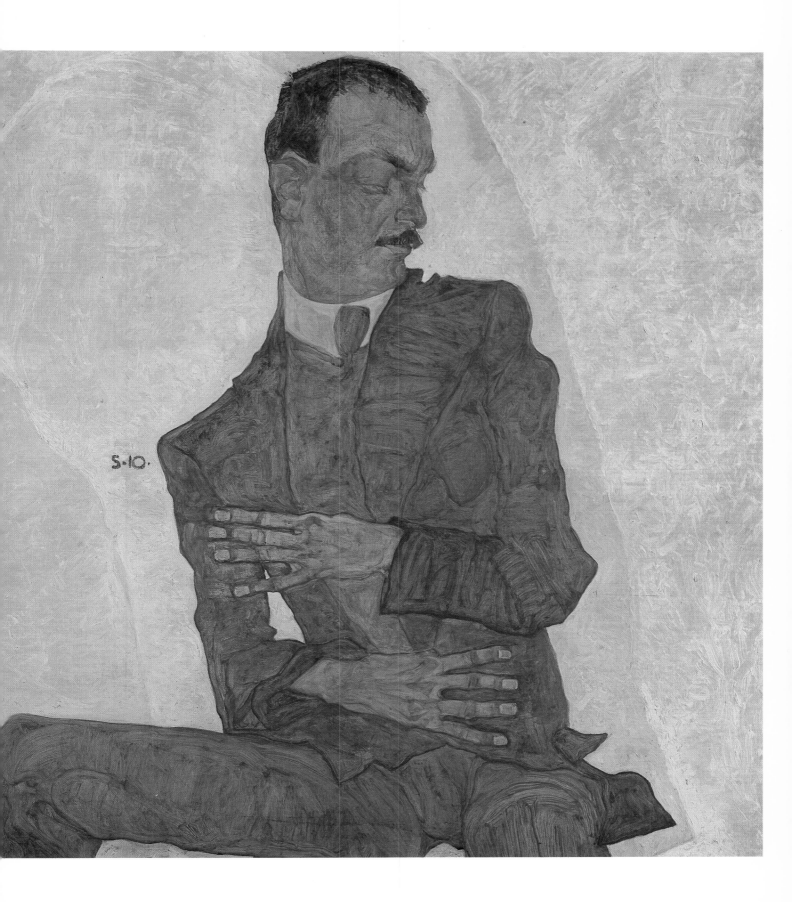

exaggerated her hands and between the thumbs he has created an unmistakable image of her sexual parts.

Undoubtedly the most striking of Schiele's early portraits are those of Arthur Roessler and Eduard Kosmack (Plates 61, 62), both painted in 1910 and both vividly expressive in their different ways of the same tensions that were appearing in the self-portraits at this time. Roessler was an art critic, an important friend and supporter of Schiele, although their relationship apparently had its stormy moments. Kos-

62. *Portrait of Eduard Kosmack*. 1910. Oil on canvas, 100 × 100 cm. (39⅜ × 39⅜ in.) Vienna, Österreichische Galerie

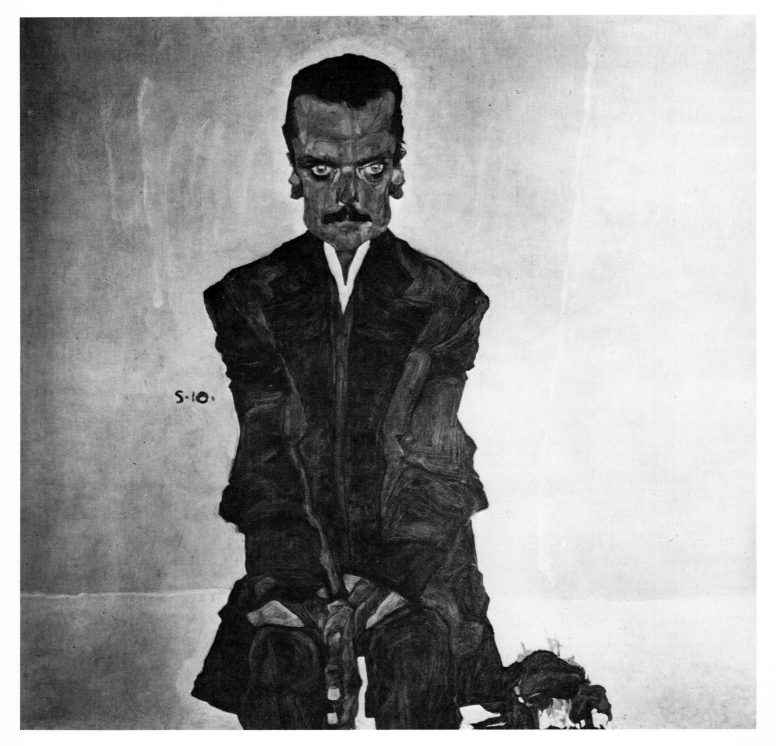

63. *Portrait of Poldi Lodzinsky*.
1910. Gouache and oil on canvas,
109.5 × 36.5 cm. (43⅛ × 14⅜ in.)
Winnipeg, Dr Ferdinand
Eckhardt

64 (left). *Double Portrait
(Heinrich and Otto Benesch)*.
1913. Oil on canvas,
121 × 131 cm. (47⅝ × 51⅝ in.)
Linz, Neue Galerie, Wolfgang
Gurlitt Museum

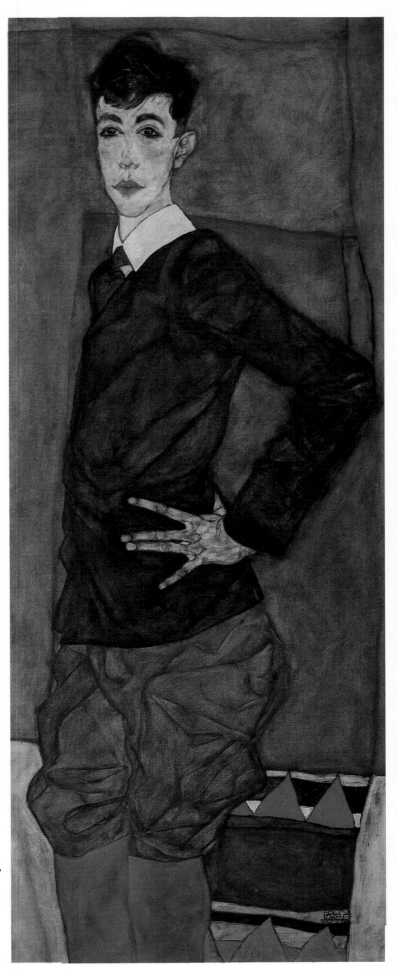

65 (right). *Portrait of Erich
Lederer*. 1912–13. Oil on canvas,
139 × 55 cm. (54¾ × 21⅝ in.)
Private collection, on loan to
Kunstmuseum, Basel

mack was the editor of two Viennese journals, *Der Architect* and *Das Interieur*, and became a director of the Wiener Werkstätte. Photographs of the two men reveal that Schiele has brilliantly captured their physical appearance while blatantly using them as the vehicles of his vision.

In spite of their personal nature it seems that Schiele's expressionist portraits excited admiration among the Viennese *avant-garde*. However, at the end of 1910 he moved first to a studio in the suburb of Meidling, then to his mother's native town, Krumau, not far from Vienna, and finally to Neulengbach. During the period up to his imprisonment, almost the only portraits of other people he made are those of his mistress Wally Neuzil. One of the last of these is a tender and affectionate watercolour of 1912.

On his return to Vienna after his imprisonment Schiele was depressed and withdrawn. In an effort to combat this condition his friend Klimt introduced him to one of his own most important patrons, the industrialist August Lederer, head of a remarkable art-loving family. The upshot of their introduction was a commission to paint the portrait of one of the two Lederer sons, Erich, at that time aged fifteen. Schiele clearly felt an immediate sympathy for his subject: in his first letter to Roessler from the Lederer home in Gyor, in Hungary, he wrote '. . . the boy I am painting is fifteen years old, with a long aristocratic face. He is a born painter and draws also, like Beardsley . . .' (Beardsley was much admired in Vienna. According to Alessandra Comini a copy of Hermann Esswein's 1912 monograph on Beardsley was among Schiele's personal effects at the time of his death.)

This initial response seems rapidly to have given way to a deeper bond and Schiele became totally engaged in the portrait project. The evidence for this is in the large number of studies of Lederer that he made both in pencil and watercolour, and then in the undoubted masterpiece in oils that he finally produced (Plate 65). It is an immensely elegant painting, perhaps the most elegantly beautiful of all Schiele's mature portraits, but there is no sacrifice of intensity of feeling: it is a hymn to youth, one of the great images in art of adolescent male beauty, pride and sensuality, a kind of twentieth-century echo of the *David* of Donatello.

In 1913, very soon after the completion of the Lederer portrait, Schiele began work on a double portrait of his friend and patron Heinrich Benesch and his son Otto, who later became a distinguished art historian. Here again personal involvement with the sitters led to an outstanding painting (Plate 64), whose significance goes beyond that of simple portraiture to become a compelling image of the father and son relationship.

In 1914 Schiele was commissioned to paint the portrait of a wealthy young woman, Friederike Beer. She was a great lover of all the arts and in particular was a passionate devotee of the Wiener Werkstätte, who designed, she recorded, 'every stitch of clothing I owned!' Intrigued by Schiele's appearance when she saw him at exhibitions she approached him through a friend to paint her portrait. The result was Schiele's

66. *Portrait of Friederike Maria Beer*. 1914. Oil on canvas, 180 × 119.5 cm. (70⅞ × 47 in.) Courtesy Marlborough Fine Art Ltd., London

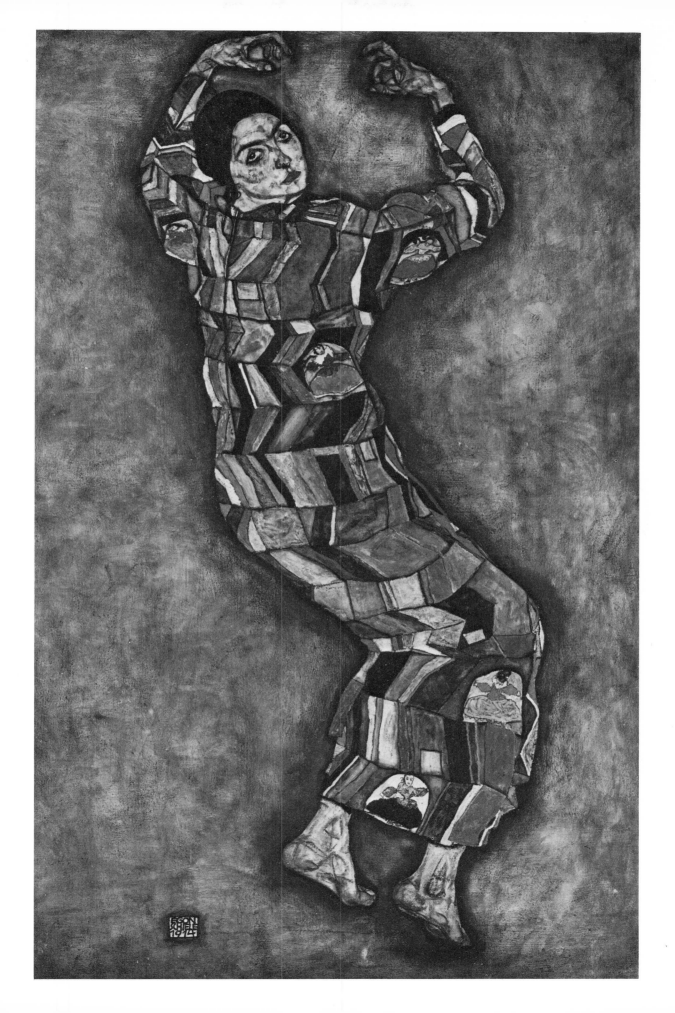

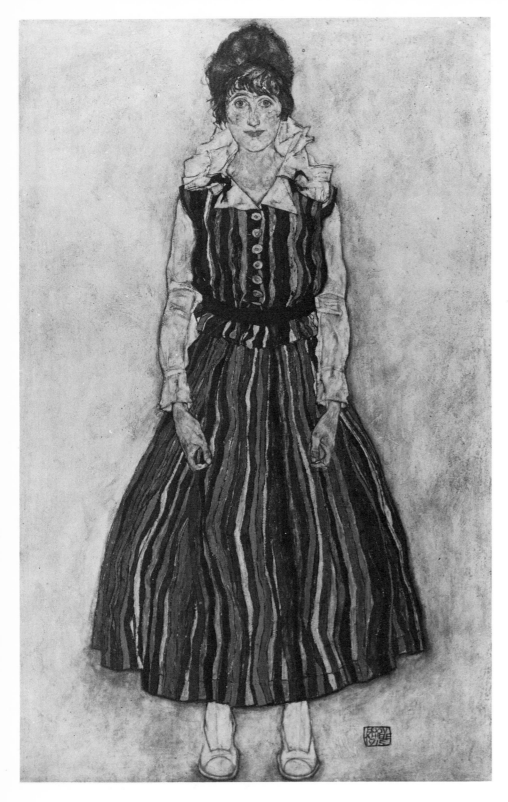

68 (right). *Portrait of Edith
Seated.* 1917–18. Oil on canvas,
140 × 110.5 cm. (55⅛ × 43½ in.)
Vienna, Österreichische Galerie

67. *Portrait of Edith Standing.*
1915. Oil on canvas,
180 × 110.5 cm. (70⅞ × 43½ in.)
The Hague, Haags
Gemeentemuseum

greatest female portrait and one of the most spectacularly decorative of
all his works (Plate 66). The figure in its multicoloured Wiener
Werkstätte robe is set like some great living jewel against a sumptuous
monochrome gold ground. Beyond this its deeper power derives from
the radical simplicity of the composition, from Schiele's use of his early
device of floating the figure mysteriously in space, from the bold zig-
zag pose that echoes the great Michelangelo *Pietà* in the Duomo,

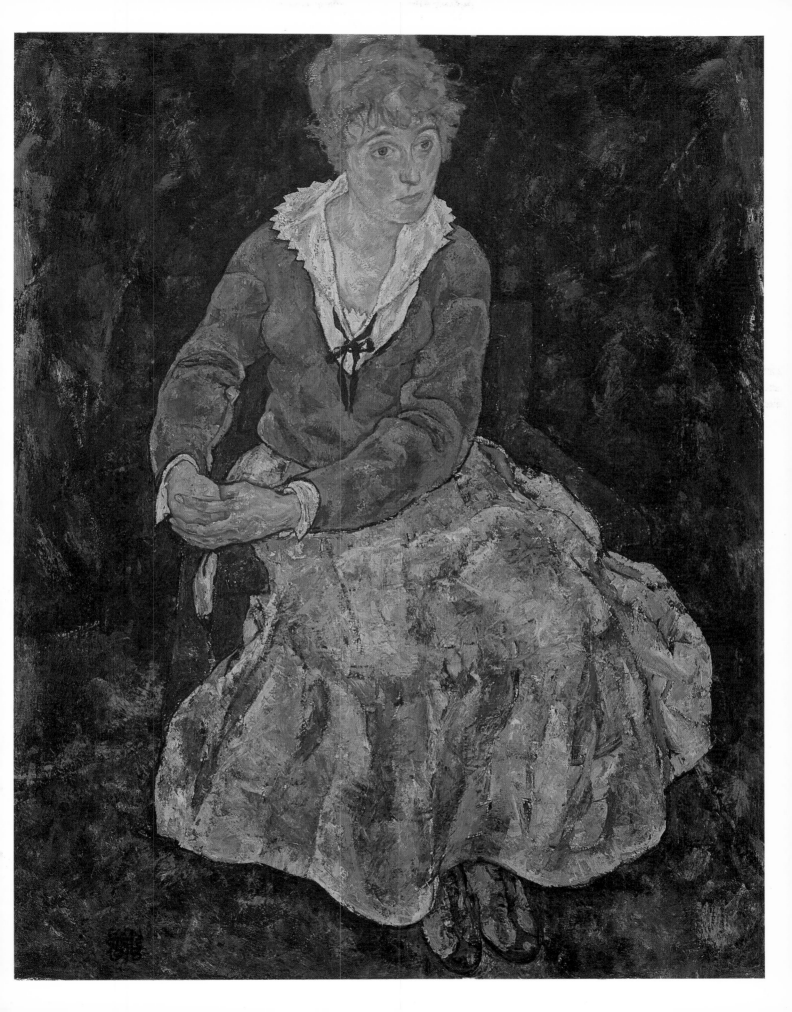

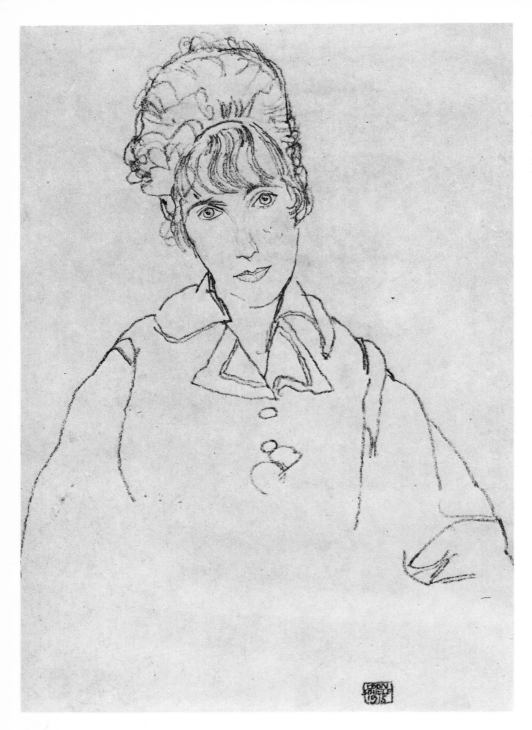

70 (right). *Portrait of Johann Harms*. 1916. Oil on canvas, 140 × 110.5 cm. (55⅛ × 43½ in.) New York, Solomon R. Guggenheim Museum

69. *Portrait of Edith*. 1915. Chalk drawing. Vienna, Graphische Sammlung Albertina

Florence, and not least from the gaunt face, staring eyes and clutching, almost claw-like hands that belong more to Schiele than to the plump and placid Fräulein Beer.

Shortly after their marriage Schiele painted the first of two very different portraits of his wife. Striking in its visual qualities, *Edith Standing* (Plate 67) lacks emotional or psychological force and seems to be an image of her as virginal bride. The second portrait of Edith (Plate 68) was painted about two years later in 1917–18 and stylistically belongs to the very last phase of Schiele's art, when his handling of the paint itself becomes denser, broader, richer and more complex than before, and he becomes increasingly concerned with creating an overall

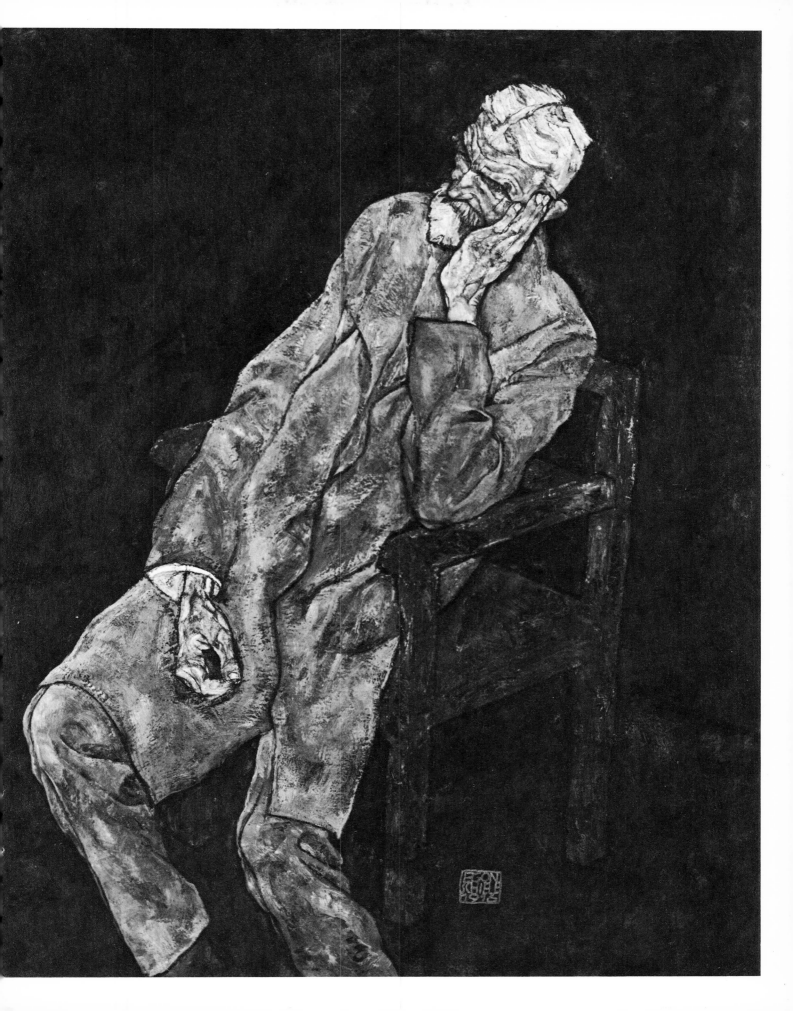

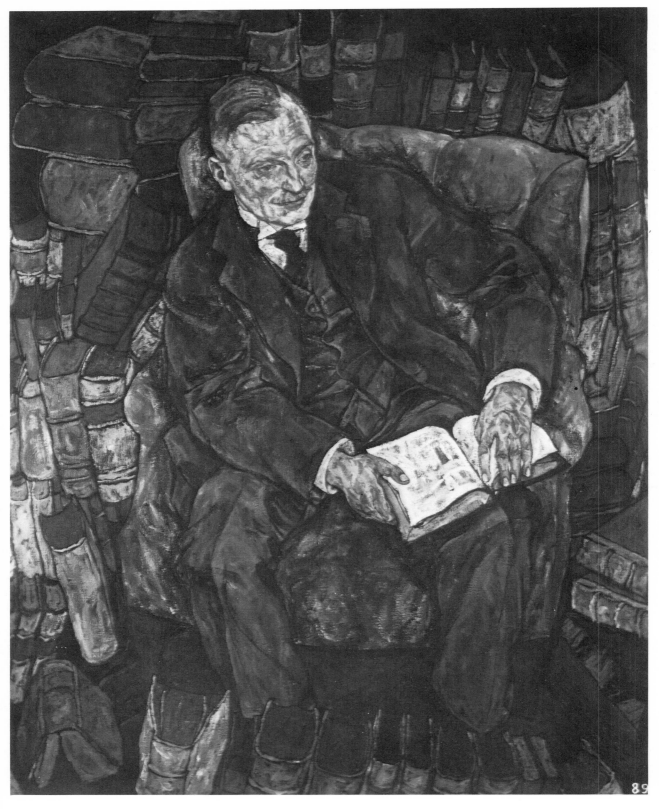

71. *Portrait of Dr Hugo Koller*.
1918. Oil on canvas, 140 × 110 cm
(55⅛ × 43¼ in.) Vienna,
Österreichische Galerie

72 (right). *Portrait of Albert Paris von Gütersloh*. 1918. Oil on
canvas, 140.5 × 110 cm.
(55¼ × 43¼ in.) Minneapolis,
Minneapolis Institute of Arts

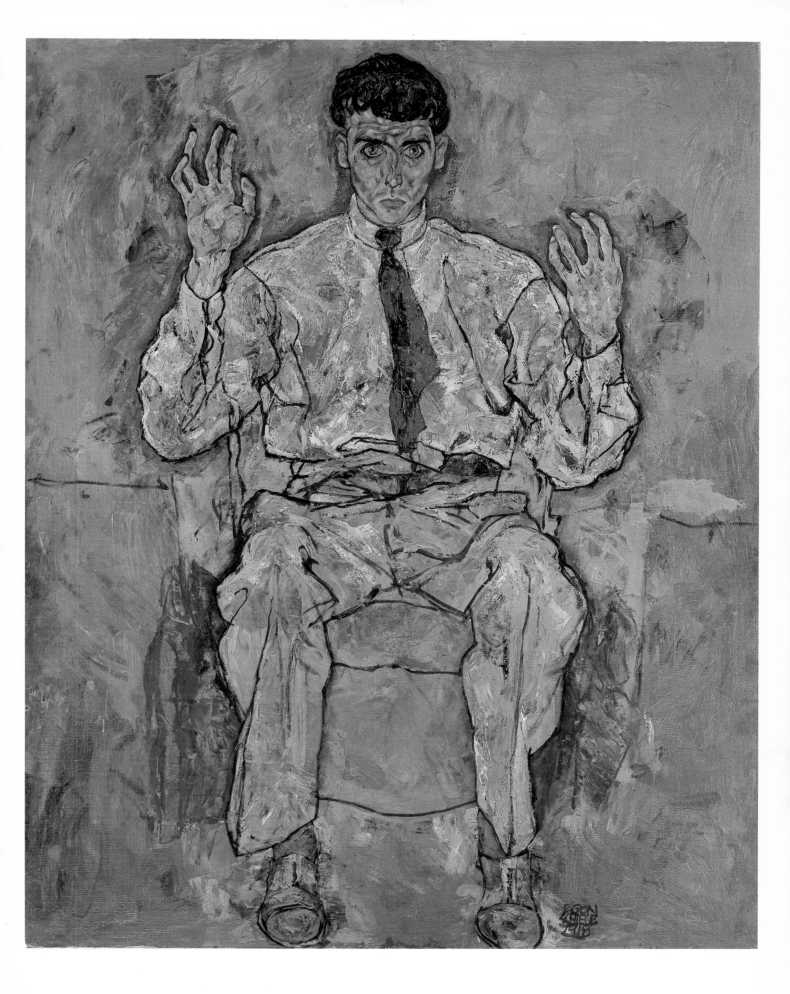

unity of effect. There is also an increasing naturalism, a lessening of distortion and tension. This development gives to Schiele's late portraits a degree of balance, harmony and unity hitherto rarely to be found in his work—they become magisterial. Outstanding examples are the 1916 portrait of his father-in-law Johann Harms (Plate 70) and that of the scholar Dr Hugo Koller painted in 1918 (Plate 71). In these works there is much less of Schiele, much more of the sitter, than ever before.

However, Schiele did paint one portrait, of his friend the artist Paris von Gütersloh, in which his new style is made the vehicle of his own deepest preoccupations (Plate 72). This, the most painterly of all his late works, is a final, monumental statement of Schiele's vision of the artist. It was left unfinished at his death.

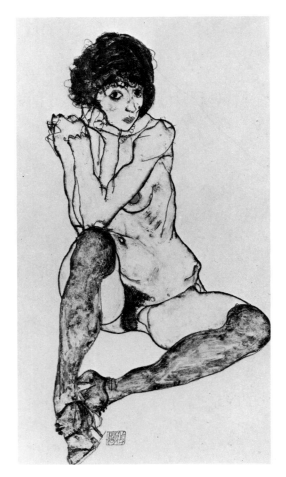

73. *Female Nude.* 1914. Gouache. Vienna, Graphische Sammlung Albertina

DATE DUE

PRINTED IN U.S.A.